W9-CLF-942

SIMPLE: WEBSITES

organizing content-rich web sites into simple structures

ROCKPORT

First published in the United States of America by
Rockport Publishers, Inc.
33 Commercial Street
Gloucester, Massachusetts 01930-5089
Telephone: (978) 282-9590
Fax: (978) 283-2742
www.rockpub.com

Library of Congress Cataloging-in-Publication Data
Mumaw, Stefan.
 Simple Web sites : organizing content-rich Web sites
into simple structures / Stefan Mumaw.
 p. cm.
 ISBN 1-56496-867-7 (HARDCOVER)
 1. Web sites—Design. I. Title.
 TK5105.888.M85 2002
 005.7'2—dc21 2001007542

ISBN 1-56496-867-7

10 9 8 7 6 5 4 3 2 1

Design: Stoltze Design
Layout: Laura H. Couallier, Laura Herrmann Design
Cover Design: Stoltze Design
Back cover images (from top to bottom):
Factor Design; New Tilt; Accordion; Overdrive Design (Rob Allen
Photography); 300 Feet Out; Akimbo Design (The North Face)

Printed in China

To my beautiful daughter,
Caitlyn. I find no joy in life
more fulfilling and more
enjoyable than the nights
she spends sitting on my
lap, in front of my computer,
finding out for herself what
Daddy does all day.

Introduction 6

1 Content Organization for Simpler Design 9

Redefining Content Presentation / Premonition Records 10

Designing with Few Assets / MacArthur Park 16

How to Communicate Just Enough / NextRx 22

Who Needs Copy / Rob Allen Photography 28

Dissecting the Content / Paul Edward Fleming 34

Designing without Content / Orange County Teachers Federal Credit Union 40

Storyboarding the User Experience / Villa Mt. Eden 46

Purposeful Content / How It Works 52

Highlighting Strong Content / John Coltrane 58

2 Using Design Principles to Encourage Visual Minimalism 65

Working with an Abbreviated Time Frame / New Tilt 66

Hundreds of Items Organized into One Clean Design / Arhaus 72

Using Navigation as the Primary Design Element / Axiom Studio 78

Design as a Subtractive Process / Red Path Photography 84

Clean, Eye-Catching Site Design Draws in Users / Golf in Austria 90

Using Color to Aid Visual Simplicity / VenusDesign 96

3 Simplifying the User Experience 103

Designing for the Design Firm / 300 Feet Out 104

Designing for a Documentary / Becoming Human 110

The Designer as Client / Accordion 116

Digital Storytelling / Birdcam 122

Design That's Driven by a Company's Philosophies / Factor Design 128

Communication as a Two-Way Street / The North Face 134

Letting the Site Map Evolve / Bam! Advertising 140

How to Inform Intelligently / BriteSmile 146

Remaining Objective about Personal Design / Kilosite 152

Directory 158

About the Author 160

Evolution is a funny thing. It has this unbearable characteristic called change that most people would rather not endure.

Designing for the Web would be easy if it weren't for that ferocious beast. If the Web would just stop evolving, designers could catch up, could develop codes of conduct and rules of design that everyone could live by. This would be digital bliss, a veritable nirvana for the self-proclaimed artistic digerati. But, alas, evolution has its calloused hand on the music box, churning the gears while we, the designers, monkey around, carrying our tin cup and clamoring for the thin sound of the client's change.

Because evolution won't take a double-tall latte break, we as designers are going to have to adapt, to change along with it. Our design principles and rulebooks are going to have to go back in the locker while we learn to break those rules in the name of effective communication.

The Web has evolved both subtly and quickly—without our approval, mind you. It has moved from a simple communication device for scholastic science departments to techno-thumping, cursor-flashing data dumps of useful and useless information. The process certainly has been imbued with digital decadence.

As the journey continues, we're increasingly finding that visual experiences online are less about how much we have to say than about what we're saying and how well we're saying it. Imagine a fairytale being told at the same time in two rooms. In one room, fifty people are each telling a different part of the tale—simultaneously. In

another room, a solitary storyteller is weaving the tale eloquently from "once upon a time" to "happily ever after." Which room would you rather be in? The movement in Web design is toward the latter. We as designers are finding that people still like to hear a well-told story. We once thought that people would rather get the story as quickly as possible and move on to another task, but sometimes effective communication means timely communication, and that is what this push is about.

Designers are moving to simpler design directions, sacrificing pages of content for visual organization and minimalist concepts. The adage "A picture is worth a thousand words" is becoming more like "A simple, intuitive navigation is worth a thousand pages of content." Designers are choosing thoughtful content-management outlines over animated GIFs and flaming logos. This approach is proving that designers who can delve into the client's purpose and emerge with a plan of attack before the first image is edited are invaluable. These are the next generation of designers—those who can listen as well as they design. The designers who can use their ears and the gray matter between them to communicate are becoming a valuable commodity in the creative market.

Designing is no longer solely about pictures and words; it is about organization and planning. Communication has turned into more of an interaction, a dialog of sorts rather than a monologue. We need to use research, strategy, and planning to organize all that we know to be true about a message, and pare it down into manageable, digestible thoughts—thoughts the audience can understand quickly. This is the challenge we now face when designing for the Web.

content organization for simpler design

Paramount to any successful online design is the effective communication of the content. Without content, the site is nothing but an empty wrapper. Content matters most, and how designers present that content should ultimately become the defining factor of a site's achievement.

The profiles within this chapter will demonstrate the many ways designers have dealt with various content-related challenges. The common thread throughout is the importance of having as much of the actual content as early as possible within the design process. When that isn't feasible, the project becomes considerably more difficult to execute.

Many times, the challenge of a particular project comes with balancing content and imagery, or the presentation of the content and not so much the content itself. These challenges pose the question every Web designer has had to ask: What's more important— form or function? The answer is...yes. And the answer is completely dependent on the goals of the project.

As it's been said many times, content is king, and without purposeful, focused attention given to what's being said and how it's being said, the project will fight an uphill battle to success.

"The simplest and cleanest visual design often yields the best information design as well."

// DESIGN FIRM: **Andrew Lin** / DESIGNER: **Andrew Lin**

Redefining Content Presentation

premonitionandmusic.com

Premonition's Web site needed to reflect the company's newfound success in grassroots jazz offerings. The site communicates well to that target audience. The navigational presentation and gridlike visual organization provide users with an easy and enjoyable experience by visually and verbally communicating exactly what the label represents: pure jazz.

Andrew Lin has a multidisciplinary background in technical and visual design. He is a member of DietStrychnine, or DS9, a worldwide alliance of freelance consultants. The designers in the DS9 alliance believe that talented and independent people work best on their own, where they want and how they want. The informal network alerts potential clients to a collection of mavericks willing to try approaches others won't.

Michael Friedman launched Premonition Records in August 1993. Its first four years produced four releases. Since then, the label's roster has tripled to include artists from across the United States.

"Premonition Records came to [Dietstrychnine] for a redesign of its current site," recalls Lin. "The plan was to keep the same content as the original, so from the beginning I knew the extent and scope of the content. Because the information was defined and set in stone, it became the focus of the site development process. The question was, 'What visual and navigational design will allow users to locate and experience the right piece of content?'"

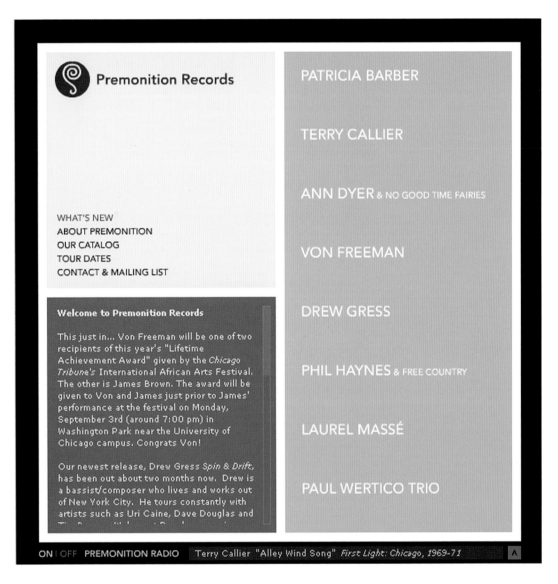

above. The two key elements keeping the site visually simple are the square environment and the muted, complementary color palette. These immediately assure viewers that experiencing this site will be easy and enjoyable.

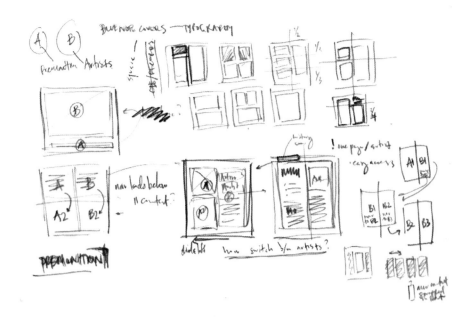

How Wireframing Can Affect Focus

Possessing all that the site is intended to communicate before the process begins gives the designer the luxury of understanding size. Knowing how large the site will be makes organizing it that much easier. The biggest job facing Lin at this point was the general architecture of the site. "The first step was to organize the content into clear and intuitive categories," Lin says. "This helps define the general architecture of the site—patterns emerge out of this process, and you begin to see how certain parts of the site may relate or be similar to other parts of the site. I prioritized each item on this categorized content list based on business objectives and user needs. Premonition wanted to highlight and promote the caliber and talent of its artists. Users would want to learn about the history and music of a particular artist and to find out more about other artists on the label. Taking these together, the conclusion was that information about the record label itself had to be secondary to content about its artists.

"Realizing that the artists were to be the heroes of the site led to initial design developments using wireframes. Visually, wireframes enabled a sketch of the priorities of the pages, content ownership of real estate, and navigational organization. Structurally, wireframes quickly allowed the design of an information and navigational architecture."

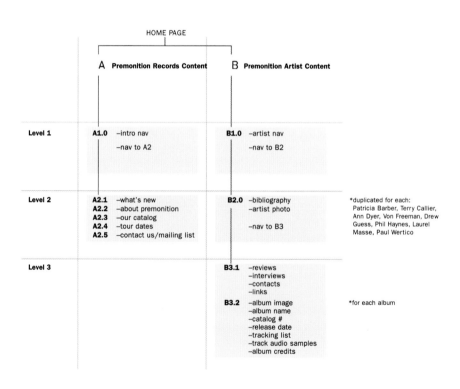

top. As the designer was working through the function of the site, he asked himself how he was going to allow users to navigate through individual artist sections. Then, on the far right of the interface, he came up with the answer—sliding the artist information over on the click of a name.

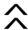

bottom. To demonstrate and document the flow of information, the designer created two site map versions, one in a hierarchy format and one in a visual format. Here, the hierarchy site map illustrates the flow of navigation and content.

left. The visual site map is driven by function. It shows how the user will move from section to section in a generic, visual way.

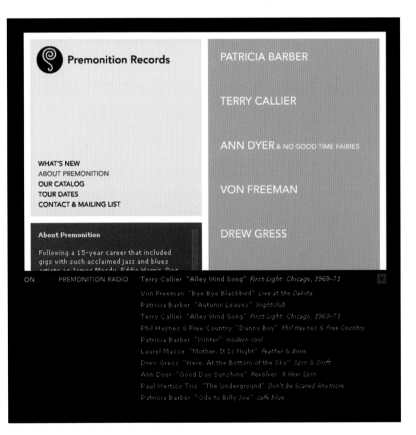

above. Record label sites typically offer an audio player so users can experience the product. Premonition's audio player remains inconspicuously at the bottom of the page. It lifts into view on request, then quietly moves out of the way.

Thoughtful Navigation Can Provide a Visually Minimal Environment

One visit to the Premonition Records site and it's immediately apparent the design is unlike most record label sites. Its square design environment and muted, contrasting color schemes invoke a relaxed atmosphere, and the navigation of the site, while complex in concept, is executed in seamless simplicity. "The thinking behind the navigational structure," says Lin, "was to present the information in a series of levels that reflect the specificity of the content—from general content about the Premonition label to specific, detailed information about an artist or a recording."

Lin explains the concept of the navigation. "The site is organized in vertical halves, with each half appearing or disappearing as the user dives deeper into the site. The user can navigate the site at three levels. The first level contains all the company and general information about Premonition Records, which loads in the lower left-hand square. Here, the most prominent elements are the navigation buttons to each of the artists."

right. In keeping with the gridlike layout, the individual artist navigation and introductory information are squared off. They also employ the same color palette as the rest of the site. This consistency helps users stay oriented as they move throughout the site.

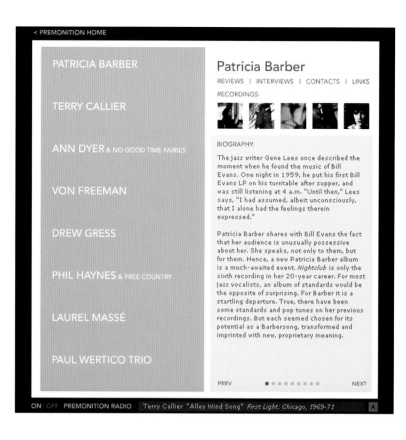

"When the user clicks on an artist, the content scrolls left, and the user arrives at the second level of content. Here, the user is introduced to the artist with a short biography and links to more information. The artist navigation still appears on the left, allowing users to quickly browse through the artists. To explore one artist in depth, the user chooses a link above the bio, and the content scrolls left again to the third content level. At any level, the user can choose to go back up one or two levels by using the history navigation in the upper-left corner.

"Because all the structural and navigation elements had been thought through in the wireframes, I was able to focus completely on the visual design of the site. The wireframes served as a roadmap and checklist for that process," adds Lin.

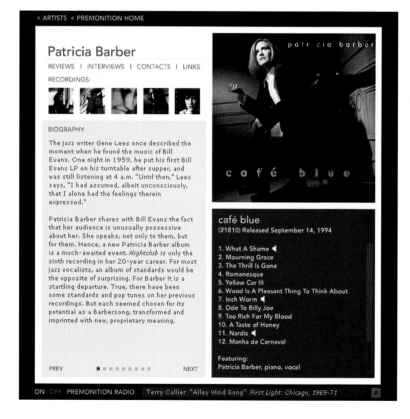

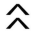

above. Once in an artist's section, the individual album information slides into the album area. This technique allows the interface to stay clean and visually simple.

Shape as a Design Element

The navigational work, reflected in the site's visual simplicity, is part its overall success. In addition, the site is visually and structurally appealing due to a combination of color, contrast, and shape that clarifies the content. "The Premonition Records site was designed using a rather rigid grid system," says Lin. "Each visual element was designed to be arranged and organized according to the grid. By following a grid system, the site offers a clear and structured view of the content."

Terry Callier
REVIEWS | INTERVIEWS | CONTACTS | LINKS
RECORDINGS:

BIOGRAPHY:

For the greater portion of four decades, singer/songwriter Terry Callier has been sidestepping the mainstream. His timeless style and compositions, captured on releases for a number of prestigious record companies, have created a fanatical following and caught the attention and praise of a new generation of artists. He has most recently appeared on Arista Recording artist Beth Orton's latest two recordings (combined sales in excess of 200,000 copies) and has now returned the favor by having Orton guest on his new Blue Thumb recording, *Lifetime*, due out February 29th.

Last year, Premonition Records was able to unearth a previously unavailable live recording of Terry Callier from 1964. The recording, entitled, Terry Callier, *Live At Mother Blues 1964*, serves as an intimate bookend to Terry's prolific career. *Live At Mother Blues* not only represents the earliest recorded full-length documentation of Callier, but also showcases

Music Review: Singer Callier Returns With Fervor
November 19, 1998

INTERVIEWS

Michael Friedman Interview with Terry Callier and producer Jeff Chouinard about First Light: Chicago, 1969-71

CONTACTS

RECORD LABEL
Premonition Records
PO Box 477621
Chicago, IL 60647
312-243-7323

NORTH AMERICAN MANAGEMENT/BOOKING
The Billions Corporation
833 W. Chicago Ave.
Suite 101
Chicago, IL 60622-5497
tel: (312) 997-9999
fax: 312-997-2287
www.billions.com

EUROPEAN MANAGEMENT/BOOKING
Meira Shore
Positive Management
23 Thornbury Rd.
Isleworth, Middlesex
United Kingdom T27 4LQ
181-568-7807

PREV ■ ■ ■ ■ ■ ■ ■ NEXT

ON OFF PREMONITION RADIO Terry Callier "Alley Wind Song" *First Light: Chicago, 1969-71*

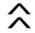

above. Part of keeping the site visually minimal is paying close attention to functionality that could intrude on an otherwise simple design. One example is the scroll bars for the content areas—the designer made sure they fit in with the design visually as well as functionally.

The Result

Lin understands the relationship between the content and the design. "While navigation is key to effective design communication, without compelling content, the site will fail in its communication goals. When designed effectively, the navigation should be so intuitive to use that it is almost transparent to users. They will be unaware of the buttons and see only the content and the information they came for."

"Visual minimalism is achieved through the methodic subtraction of visual cues to produce a message in its purest form."

Designing with Few Assets

macarthurpark.com

MacArthurPark.com is a site that visually describes the film so well, there is little doubt as to its overall mood or the seriousness of the situation the film presents. Navigation is intuitive yet doesn't depart visually from the design of the site. Using Polaroid snapshots and rough, urban typography, the designers at vFive succeed in not only showing images from the film, but also in creating and extending the mood of the film through this simple imagery.

Founded in 1996, vFive is a full-service design and development firm. Based in San Francisco, the designers and developers work side by side on tightly integrated media projects that fulfill both aesthetic and technical needs.

MacArthur Park is an independent film that premiered at the Sundance 2001 film festival. It tells the story of one man's struggle to survive the dark realities of life in the streets of Los Angeles. vFive was responsible for creating a pre-Sundance promotional site that would generate buzz around the film and raise its visibility. The site contains general information about the film and the people behind it. More importantly, it acted as a mood-setter for people anticipating the screening and as a hook for potential distribution deals.

MACARTHUR PARK PREMIERED AT THE 2001 SUNDANCE FILM FESTIVAL

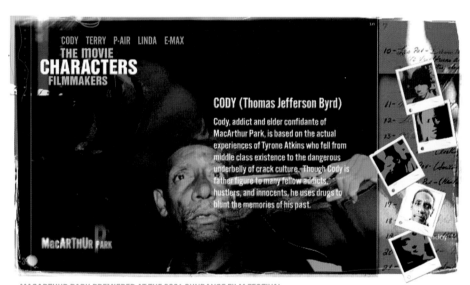

MACARTHUR PARK PREMIERED AT THE 2001 SUNDANCE FILM FESTIVAL

top. Although the subject matter is relatively serious, the site uses a simple two-column layout to separate content from navigation. This allows the designers to overlap imagery between the two areas without confusing the viewer.

bottom. The iconography of the Polaroid images as navigation markers enhances the site's overall push for consistency between the movie and the site's design.

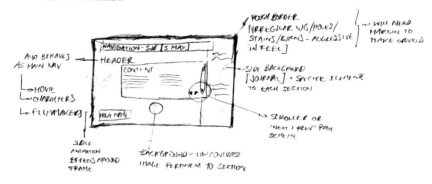

right. The designers show their reason
for the stark white contrast in the upper
right of this sketchbook page. They
wanted an aggressive edge to the content
to mirror the mood of the film and needed
a stark border to accentuate this effect.

When Designers Are Given Too Little Content

Describing the early position of the project, Erahm Machado, creative director for vFive, remembers the initial obstacles. "The process implemented to design the *MacArthur Park* site was unique for a number of reasons. Specifically, the site was based on an independent film that had not acquired distribution; the film was based on a true story; the film was still in post-production, limiting the availability of source materials; and the development time was limited to two weeks. We had to adopt an unconventional design process that would allow us to meet the project goals and deliver the Web site on time."

The challenges the project presented were intriguing to the team. Time did not allow much opportunity to tweak the project. The organizational problem was unusual—what to do with too little content. It is just as important to organize a small amount of content as it is the vast amounts most clients ask to be included. Machado recalls, "We told the client that we wanted to develop the site around a concept that related directly to the film. Because the film was independent and told a compelling true story, we wanted to make sure that the site reflected those facts. We laid all of our notes and assets on the conference room table and brainstormed on how to accomplish our goals."

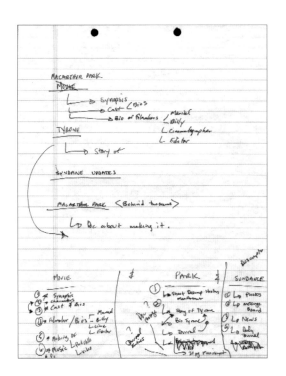

above. It is often useful to work through
the preliminary site architecture before
drawing up the formal documents, as the
designers did here. This allows the site
map to evolve slightly while details are
being worked out.

MACARTHUR PARK
PROPOSED SITE LAYOUT AND STRUCTURE

Flash Interface

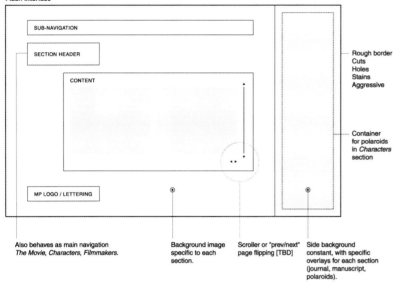

SUB-NAVIGATION

SECTION HEADER

CONTENT

MP LOGO / LETTERING

Rough border
Cuts
Holes
Stains
Aggressive

Container
for polaroids
in *Characters*
section

Also behaves as main navigation
The Movie, Characters, Filmmakers.

Background image
specific to each
section.

Scroller or "prev/next"
page flipping [TBD]

Side background
constant, with specific
overlays for each section
(journal, manuscript,
polaroids).

Information Architecture

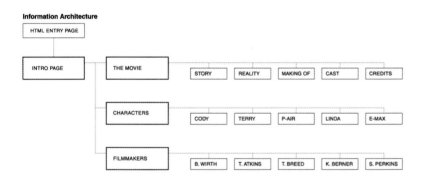

HTML ENTRY PAGE

INTRO PAGE

THE MOVIE — STORY | REALITY | MAKING OF | CAST | CREDITS

CHARACTERS — CODY | TERRY | P-AIR | LINDA | E-MAX

FILMMAKERS — B. WIRTH | T. ATKINS | T. BREED | K. BERNER | S. PERKINS

vFive

MacArthur Park Site Layout - Page 1

above. The designers chose to design
the information architecture to explain,
in general, where elements would be
placed. This method provides structure
to the design and production team
while allowing the flexibility of moving
information around as needed during
the design process.

Focus on the Core Message

With few assets to work with, the development team needed to do an exceptional job of communicating the focus of the site using visual design philosophies and intuitive interface structures. They accomplished this collectively, using the dark mood of the film to initiate creative direction. "With all of our sites," says Machado, "the *MacArthur Park* site included, we examine the raw content supplied by the client for the core message or feeling that the site intends to evoke. Once we've identified the core message or messages, we form our own definitions of what the design should reflect (based on the goals of the site). These definitions usually consist of a few words that can be used in making design decisions—colors, typefaces, photographs, textures, shapes, etc. As we begin shaping the design, we experiment with different ways of combining those elements without fear of taking unexpected turns.

"Throughout the entire design and development process, we always refer to those few defining words to stay true to the core message. A successful final design elevates the value of the content and blends in to become part of the content—that is our aim. During the development of the *MacArthur Park* site, we tried to accurately represent the character of the film. The scrapbook elements are the link to the real-life character, Tyrone," Machado adds.

When Simplicity Becomes
the Result of Reflection

In keeping with the theme of the movie, the designers wanted the site to feel basic but not barren. The diary on which the film is based is crude and to the point, and they wanted the site, in design as well as in the presentation of information, to be simple because the main characters were, in some part, simple themselves. "Visual minimalism is achieved through the methodic subtraction of visual cues to produce a message in its purest form," Machado notes. "By removing elements that don't contribute to the core message or feeling, the designer's efforts can be dedicated to the perfection of the key ingredients that compose the design.

"For the *MacArthur Park* site, we created everything around the story. We never explicitly intended to create a traditionally minimal look. We wanted to express the angst and grief we found in the main character's journal. The monochromatic look, with subtle rust hues and high-contrast type framed within a weathered black background, captures those feelings. The content dictates the design; thus, the execution conveys simplicity and reason. As designers, we look at the nature and purpose of each project before we dictate its visual treatment. It's important to let the unique characteristics of the assignment develop the personality of the design—free of preconceived ideas of what the outcome should be. For the *MacArthur Park* site we did just that."

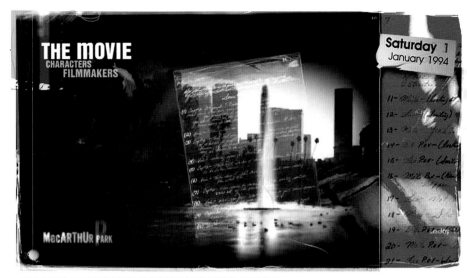

MACARTHUR PARK PREMIERED AT THE 2001 SUNDANCE FILM FESTIVAL

MACARTHUR PARK PREMIERED AT THE 2001 SUNDANCE FILM FESTIVAL

top. The typography is well-chosen. The designers used a slightly irregular typeface to keep the viewer on edge without cluttering the interface with messy fonts.

bottom. The stark contrast of the black site on the background is easily the most recognizable design element used to portray a simple structure.

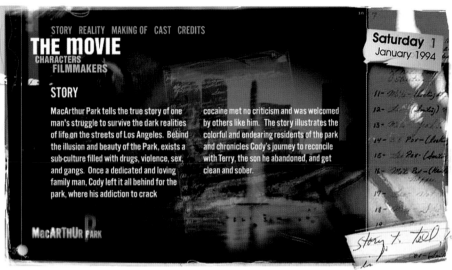

MACARTHUR PARK PREMIERED AT THE 2001 SUNDANCE FILM FESTIVAL

When confronted with a blank canvas and given very few paints, it often helps to start from the genesis of inspiration—mood. In figuring out what needed to be said and how it was to be presented, the team at vFive chose to throw everything they thought about the project up for evaluation and inspiration. Says Machado, "The first step of the design process was to define the overall personality of the site. We created a mood board that included collected photos, images associated with the theme, original pages of the manuscript, production stills, pictures of props, colors, and type samples. This helped us sculpt the site's look and feel to resemble something Tyrone would have conceived. Our designer took elements from the mood board and selected the images and elements that best helped attain the goals defined early in the process—maintain character and promote the film."

above. The torn paper for the secondary header elements brings into focus the purposeful segregation of single elements on the page. The content, the header, the primary navigation, and the secondary design elements each carries its own visual weight.

The Result

As narrative site design goes, the team at vFive has created a site that mirrors the subject well and tells the story as effectively as possible. "When designing a Web site to present narrative material," says Machado, "you have to create a user experience that helps characterize the story. The design must establish a firm relationship between the content and the essence of the story to effectively engage the user in the experience. The content provided for the *MacArthur Park* site was limited and unrefined, so we were forced to repropose original content for the site design. In order to implement the proposed concept, the designer dissected the supplied content and sculpted it into an original design that reflected the imagery described in the story. Each design element helps create a unique user experience that emulates the style of the film."

How to Communicate
Just Enough

nextrx.com

The NextRx site, through the use of appropriate color and layout, encourages users to inquire further. Negative space and a visually minimalist approach that draws attention to the content provide a wonderful contrast to the strong color usage. The controlled design environment and short, focused copy add to the simplest design approach.

Hornall Anderson Design Works strives to become a branding and communications partner with their clients by taking an active role in solving their problems. They help define and interpret a company's actions and values while facilitating a process of thinking. This results in a form of cognitive design. The purpose at Hornall Anderson is not just to turn heads with great design but to create a meaningful interaction that brings their clients face to face with their audience.

The NextRx Web site is actually an extension of the brand Hornall Anderson created with the company in 1998. "We collaborated with NextRx on everything, starting with their name," recalled Merran Kubalak, executive producer of the NextRx project at Hornall Anderson. "NextRx was essentially the new kid on the block and wanted to create a buzz about their business without revealing too much to their competitors. We analyzed their competitive space and found it awash in a sea of white, red, and blue, and it was wordy and predictable, too. Starting with color (purple, black, and orange) and the name, Hornall Anderson and NextRx partnered to successfully launch a brand that challenged hospitals and pharmacists to reexamine their practices."

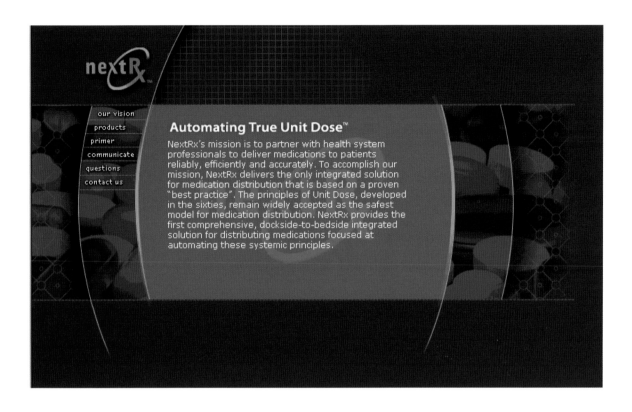

above. Shade and contrast were used to differentiate the shapes, helping define the positive and negative space while maintaining a virtually monochromatic page.

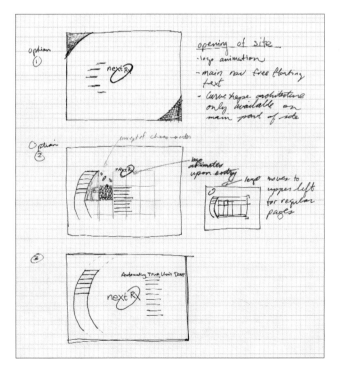

above. The designers provided home page design options for the client to generate discussion and help with feedback.

Getting to the Point

The overall design of the site is a perfect example of the Hornall Anderson philosophy of design: "Be direct and concise, and use singular, profound imagery to back it up." The team was able to follow this rule to guide the site from design through production. Says Kubalak, "In broad strokes, three design elements speak to visual minimalism: direct messaging; simple, logical color palettes; and a respect for negative space."

"The Web seems to attract clutter. Often, the instinct is to place as much information as possible on a Web site because you can. However, our team realizes that the tradition of protecting negative space and using it to emphasize the importance of content and to effectively communicate the client's message is vital to success. Essentially, the design challenge remains similar whether the team is creating a printed piece or a Web site—communicate only as much as you need to in order to get the message across. Be smart about color. Use simple, logical color palettes that work directly with the messaging and overall brand. White isn't necessary, but the chosen color does have to work with the brand and allow users to access the information with minimal effort."

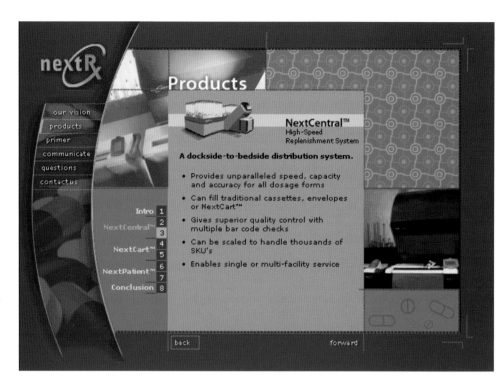

above. The contrast of dark blue and olive green brings the attention of users to the information that the designers want them to absorb.

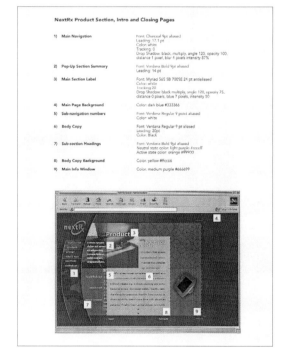

above. Whether for the client or for the internal design team, a spec sheet of style guides keeps everyone on the same track.

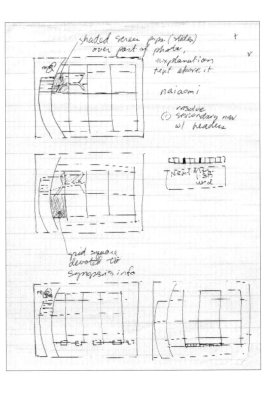

left. A combination of comping and storyboarding processes allows the designer room to work through presentation details visually.

Just Enough Voice to Be Heard

The challenge with the NextRx site was to communicate enough information to make potential customers inquire further without revealing too much information to the competition. The site was not intended as a source for detailed spec sheets on a highly complex product offering. "In designing the Web site," says Kubalak, "the design team was able to express the client's renegade spirit as an innovative way of looking at what was, essentially, teaser content. In purposefully creating a minimalist feeling graphically."

Thus, how the site presented content and how users navigated the site was vital to the achievement of its goals. "Navigation and content are the key elements in site usability," notes Kubalak. "The most innovative and effective design will fail without a strong, intuitive navigation system as its cornerstone.

Ideally, the navigation system and the design aesthetic are conceived simultaneously and produce a symbiotic relationship."

"So much of the inspiration and fluidity of a site depends on the marriage of design and content. Additionally, knowing that the content may change as the site grows is vital to successful design. Our team has found it useful in sites where we know the specific content will change weekly or monthly— for example, a magazine section— to develop the client's overarching concepts or purposes for those sections. We narrow in on the stable ideas that will influence all content in those sections."

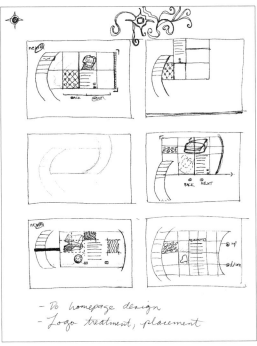

above. The designers were working out the presentation and navigation of content before the placement of corporate identity had been finalized.

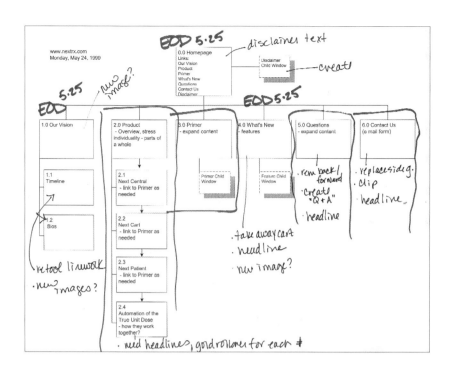

Content Up Front

To emphasize proper content management and presentation, the Hornall Anderson team needed to identify everything that NextRx wanted to say and everything they didn't. It was essential to have as much of the actual content as possible prior to design. "We generally require ninety percent of the site content during preproduction and prior to information architecture and design," says Kubalak. "If we do not have actual content, we request or provide assistance in deciding on content subject matter, length of copy, number of images, and so on. If asked to begin with client copy, we review it and may recommend copyediting for Web use. Often, we partner with a writer and create content specifically for the Web site. In those cases, we ask that the client provide a set of guidelines so that content can be updated as needed. The writer may continue to work with the client not only on Web content but also on all brand messaging."

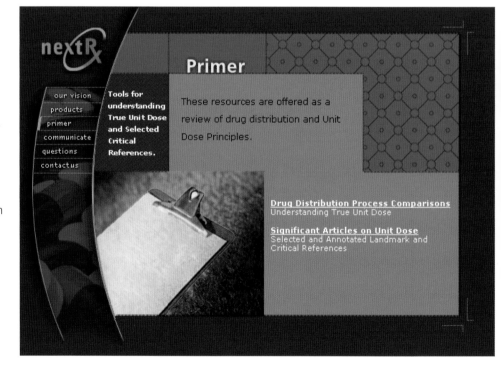

top. The wireframe not only provides the navigational roadmap of the site but also gives the designers an informal to-do list to follow.

bottom. Descriptive titles to the right of the navigation appear on rollover, giving the visitor a glimpse of what is in that section. Rollovers are an easy way to keep the design clean but full of content.

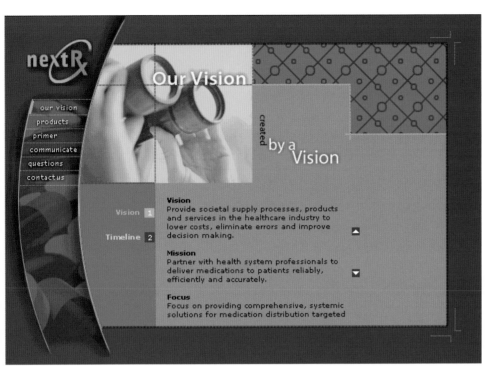

left. To control the design environment, the designers squared off the end of the content area. This allows users to view the content in a contained, controllable environment.

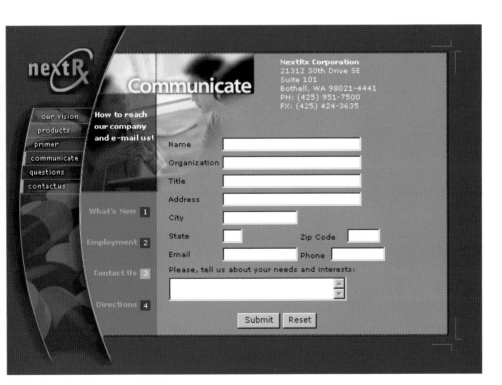

The Result

above. An aliased typeface, one without smooth edges, was used on the navigation to increase the legibility of the words at small font sizes.

"We feel that each site needs to have design that is appropriately complex," says Kubalak. "Most important, the design must anticipate what has motivated the user to visit the site and must effectively respond to that drive. We succeeded for NextRx through their Web site by planning on a controlled color palette and restrained, simple navigation, creating a grid that spoke to the way the product worked and became a metaphor for the site, allowing control, structure, and precision."

"If an element of the site cannot be rationalized in an articulate manner, then it doesn't belong."

Who Needs Copy?

roballen.ca

The Rob Allen Photography Web site is an example of striking simplicity, void of excessive imagery and needless copy. It doesn't even offer any information about Rob Allen, the photographer. If potential clients are convinced that the work is good, he believes, they won't care where he went to school or what his mission statement is.

Overdrive Design Ltd. burst onto the scene in 1987 through the boundless energy of its fearless leader, James Wilson. With his partners in crime fighting, James battles evildoers in the arena of new media and design communications. They have a simple mantra they live and work by. "Beautiful aesthetic is always a natural byproduct of our design process," says Wilson. "There is beauty in successful design."

Rob Allen Photography is the natural extension of a hungry mind and a desire to understand the world, especially people. Allen's style is distinctively void of color, focusing on the beauty and simplicity of black-and-white images and concentrating on the capture of light and contrast. His photographic subjects are usually people.

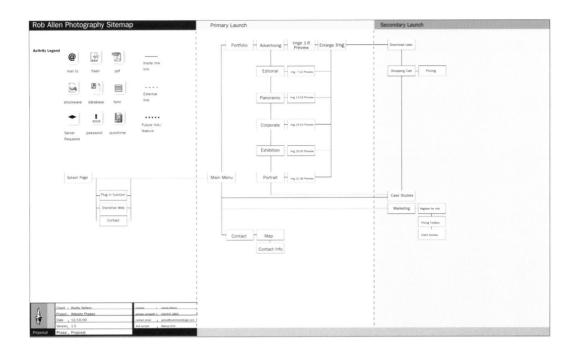

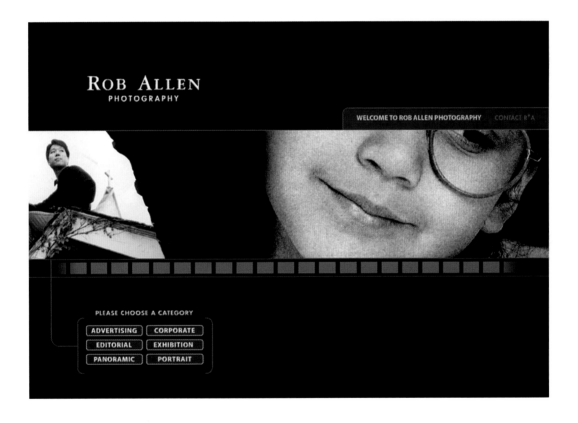

top. Not only did the designer map the flow of information for this initial stage of the development, he also mapped a scheduled second-stage launch to determine how upcoming new information would integrate with the existing site.

bottom. The designer chose to include only the portfolio sections in the navigation. No other areas were needed to fulfill the objectives of the site.

A Consistent Theme through Most Photographers' Sites

Why are so many photographers' Web sites designed so well? Is it because of the nature of photography, the aesthetic of the medium? Is it because photographers and designers have a similar perspective on life and design? Or is it that photographers, more than other professionals, care less about words and information and more about the visual advantages the Web provides? Photographers' Web sites are rarely saturated with copy, endless paragraphs of gibberish, banner ads, and animated gifs. This is because photographers have a deep understanding of the spatial aspects of design, the necessary relationship between positive and negative space.

The team at Overdrive Design certainly feels that a minimalist approach to this project was the right direction. When asked about the state of design on the Web, Wilson pointed the disciplinarian finger at the lack of purposeful thought, which results in poorly designed sites. "I feel that the vast majority of sites are not reflective of critical thinking," he says. "They may demonstrate strengths in areas such as style components, user interface, or idea, but few companies put it all together well or at least consistently well. More purposeful visual minimalism is appearing but, in my opinion, it is not a trend but, rather, it is because more designers are out there, which increases the number of good designers out there. Also, the Web has had some time to evolve and mature, so it's more understandable as a medium."

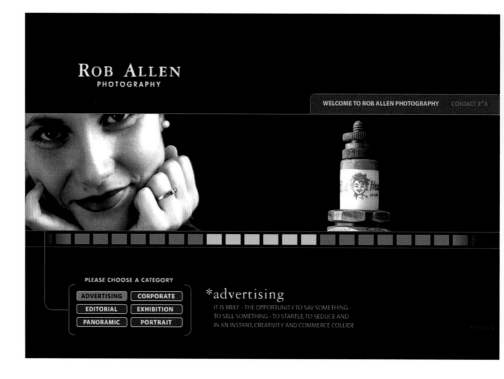

above. The only colors that appear in the black-and-white environment are used to differentiate the portfolio sections for the user.

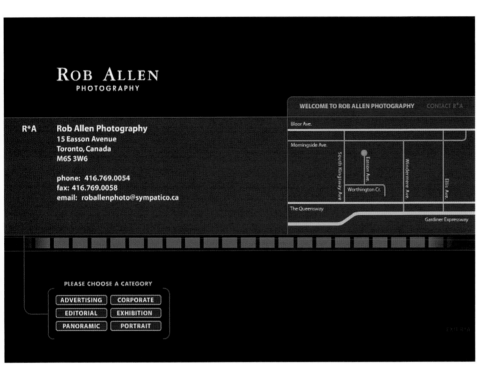

above. Only the most basic information was included in the contact section. No more was needed.

Even with Little Copy, Organization Is King

The Rob Allen Photography site has benefited from Wilson's critical thinking. The site contains an abundance of photography examples and almost no copy-driven content. Even the descriptions that accompany the photographs are treated as design elements. Wilson and his team sought to display the pictures intuitively and naturally without overdesigning the interface, so they started the design process with simple organization.

Controlling the flow of information can help better communicate the core by presenting content in a structured way, in an order designed to be seen. The designers wanted the content to have a linear flow, almost like a story, without leading visitors down a prescribed path. They started with a site map. "We're all visual people here, and flowcharting helps simplify the information for us," says Wilson. "We made the site map at the outset of the design process."

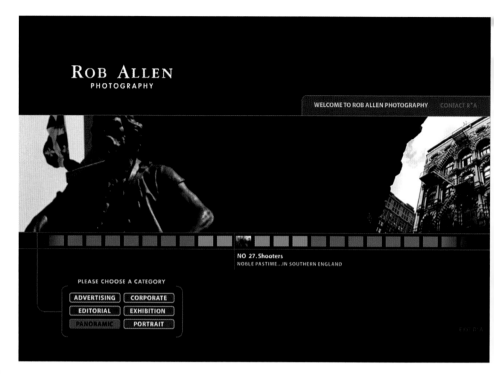

Why Early Content Collection Is Crucial

Overdrive wanted to gather as much content as possible at the beginning. "We collect all of the content up front," says Wilson. "It does not have to be final, however, and may exist simply as a draft or a series of PowerPoint presentations from which we can extract ideas."

The Rob Allen site is a perfect example of why it is good to have content from the beginning. Without seeing the photographs, the designers may never have noticed the pattern throughout a majority of the work—most of the pictures are in black and white. This has deeply important design implications, as the site designers can better communicate the message by knowing what the message is.

above. The color relationship between the portfolio section button and the portion of the image line that accompanies the section is a subtle, but effective, method of collation.

Navigation Should Bring Focus to the Content

The key functional element in the site was the navigation. How would users thumb through this vast collection of work? The site map indicated to the designers the direction of the site, but their navigational philosophy guided them through the door. "Other than content," says Wilson, "navigation is the most important single element involved in making a site understandable. Our approach is fairly clear. We like to keep navigation localized; we don't spread it around the page. We keep it simple, keep the fancy technical bells and whistles stuff to a minimum, and keep it small and secondary. Navigation is not a means to its own end. Content is the point and, therefore, should be the focus."

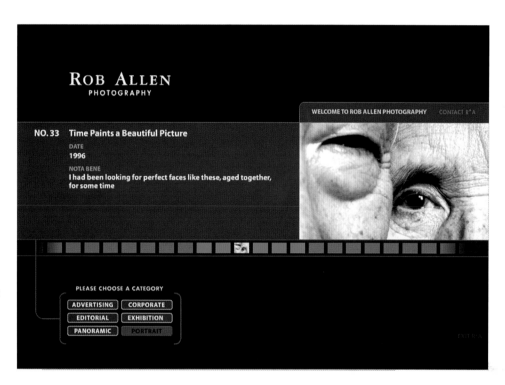

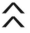

above. Because of file size considerations with photograph-heavy sites, the designer uses other images only when necessary.

The Result

It would have been easy to display all of the many photographs at once, but that would have detracted from the character and integrity of each. Overdrive chose to hide the thumbnails until mouse-over, a detail that upheld the simplicity of the site and created a natural environment in which the photographs could take center stage. "If a detail's existence cannot be rationalized," Wilson says, "then it should not be included in the design."

"Minimalism produces a clearer overview of the information, allowing users easier legibility due to less clutter."

Dissecting the Content

pauledwardfleming.com

The Paul Edward Fleming Web site is a personal expression site that differs from most in that it is intelligently designed and functionally proficient. By using defined spaces for imagery and writing Web-specific, short, focused copy, the designer provides the user with a simple and easily understandable interface in which to explore.

Paul Edward Fleming has been developing innovative design for clients since graduating from college as a print designer in 1994. His personal site reflects not only his capabilities but also his exploratory nature as a designer. "Pauledwardfleming.com was an opportunity to express myself creatively," Fleming says. "No rules, no clients—just me and my design. It also worked as a testing ground, a place I could produce complex navigation systems in simple layouts."

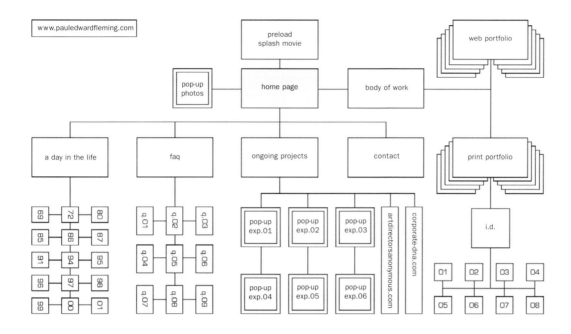

www.pauledwardfleming.com

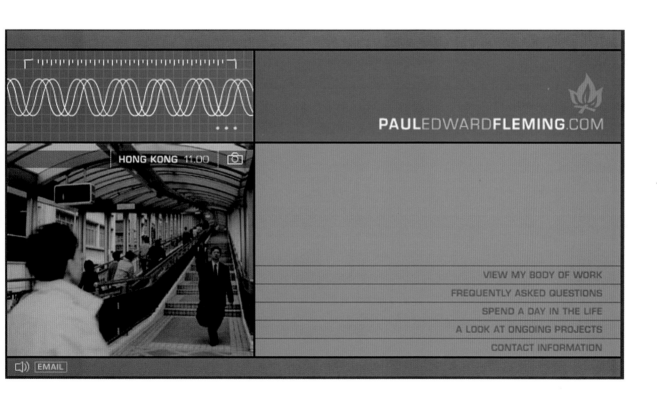
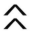
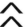

top. Even the most intimate of subjects, the self, needs to be defined and organized into meaningful, palatable sections. Without these methodical structures, information can get buried and users can get lost.

bottom. The designer created a site that allowed him to incorporate a unique, interactive navigational system. The navigation is, in many respects, the content, and it provides a venue for showcasing his design skills.

The Art of the Personal Site

It's not unusual for designers to create sites as experimental gatherings of thought. They use the sites to work through ideas and see which thought patterns can lead to new, inventive ways to accomplish goals. "Developing my site was an opportunity to experiment and discover new ways in which I could enhance interactive communications and, in turn, translate those results into my commercial work," says Fleming. "The site started as a series of small navigation and visual layout experiments. I looked at ways to attract user attention by experimenting with form, motion, and color. I discovered that the simpler the layout, the more focus was drawn to the dominant object. In the case of pauledwardfleming.com, that object was my work. And so the site was born. Now that I had the right direction, it was time to step back and plan the project properly."

Although the creation of these idea farms is not unusual, the amount of thought and design-oriented preparation that went into this particular site is. "Building a complex site requires a great deal of planning," Fleming says.

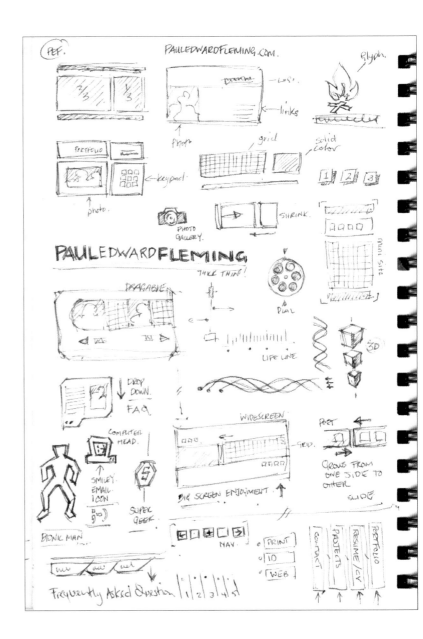

above. This sketchbook page shows a designer not only working out the major design details but the minor decisions as well, leaving nothing to chance during the development stage. This ensures a predictable and desired result.

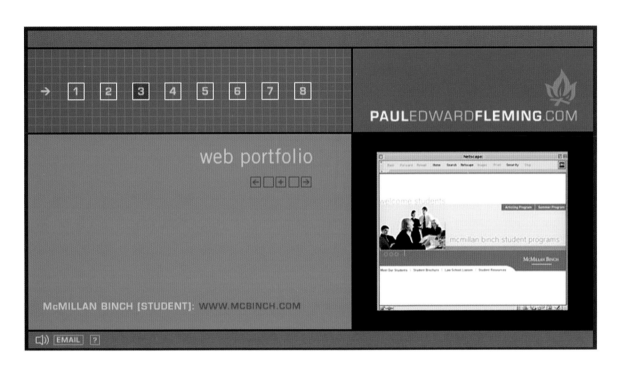

above. The designer made a conscious effort to surround content with large amounts of negative space. This creates a visual vortex, leading the user into the content rather than the interface of the site.

"The easiest way to start, I find, is to create a visual layout in the form of a hierarchy. This way, when working deep inside the site, at any time I can see at a glance exactly where the information goes. I decided on five main sections, starting with the home page. My design was taken mostly from sketches and the odd idea floating around in my head. Another crucial step is to consider the secondary page format and placement of content. I knew the success of minimalist design was dependent on my ability to maintain consistency within my page structure and simplicity in the transitions."

"In the design section, for example, I wanted users to focus on my work. To achieve that result, I turned to one of my earlier experiments. The top navigation leads to each client's examples, then a second, very subtle navigation allows users to shuffle between the clients' pieces. Because the navigation is such a simple element, all the energy is moved to the work displayed. Even the clients' name and links were worked as an element of the overall design."

Evolution Can Begin Anytime

The great thing about these thought factories is the notion that the site can evolve as the designer is building it. Often, ideas roll in quickly, and implementing them yields unexpected results. "After the design section, I managed to move into a kind of rhythm. The Day in the Life became a timeline, the FAQ section became drop-down cue cards. I was taking readers on a journey of discovery. In each section they could uncover as much or as little information as they wanted. To me, it was almost like storytelling—which led me to create the text as a conversation with the viewer, a friendly voice rather than just words. It was then just a matter of dropping the information into the appropriate slots, and I was nearly there."

Navigation for these types of sites is often an afterthought that is subordinate to the content. Fleming believes that although the site was an exercise in personal expression, it was also a personal business site and so in need of thoughtful navigation. "Navigation is paramount; it is the backbone of a well-thought-out site," says Fleming. "It has to work seamlessly with the overall design and be intuitive. For this to happen, it must be top of the list during the design and planning stage. The bottom line is that if the navigation fails, the site fails."

"When working on pauledward-fleming.com, I had the freedom to explore, as my mission was specifically to test the limits of effective navigation. In each section, by building simple challenges and creating fluid transitions between the blocks of information, I could engage users and encourage them to discover more."

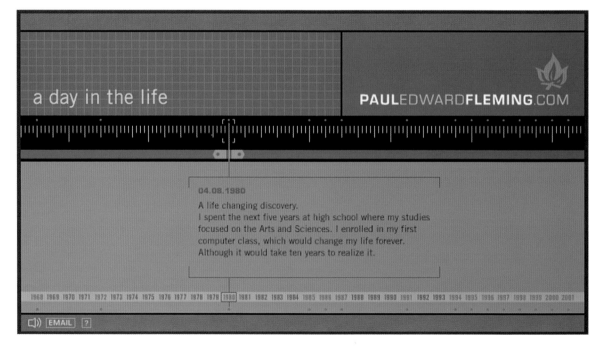

above. In a clever presentation for a personal biography, the designer chose to use a day-in-the-life metaphor to bring up content one nugget at a time. This method allows the designer visually appealing negative space to work with.

Breaking Content into Bite-Sized Chunks

Content for this site was obvious—portfolio projects, contact information, and experimental idea chunks. Fleming wanted to expose viewers to the right amount of information at all times. "As part of the design phase, I was able to determine the voice I needed to use and the imagery that worked best," Fleming says. "As the site was a personal project, I created all the content myself. In a minimalist-style site, this was a real advantage, as I was able to control the amounts of copy and create bite-size blocks of information. These were easily integrated into the simple layouts for each section. With so much to be said, it made sense to build the content into bite-size morsels that viewers can quickly absorb and then move on. I didn't want users arriving at a page and being so overwhelmed with information that they simply bolted."

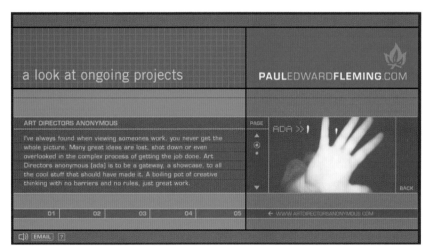

top. Color and space define the areas dedicated to content. Nothing crosses the border on purpose within the site.

bottom. The site's gridlike interface separates content and navigation, provides visual variance and interest, and allows for future content additions to be built easily.

The Result

"To me," says Fleming, "minimalism is the simple use of clear, open space and objects. An area can look filled but uncluttered. In the case of pauledwardfleming.com, large blocks of color were used that symbolize content but feel like negative space. Even the elements that make the page are simple in their design. Structured shapes are organized in a grid pattern and held together by an invisible keyline. The entire site floats on a sea of dark gray, adding to the mood of tranquility and simplicity."

Designing without Content

octfcu.org

The Orange County Teachers Federal Credit Union Web site is a financial-institution site unlike the competition's. With particular attention paid to space and contrast, the design team at Big Man created a site that is simple, clean, and extremely easy to use. Using light-hued colors and dedicating specific space and size to imagery, the interface feels open and friendly, reiterating the financial institution's desire to appeal on a more personal level with the customer. Navigating the site is effortless. Its consistency throughout the site additionally assists users to find needed information.

Big Man Creative is a small graphic design firm in Laguna Hills, California. Specializing in Web and multimedia design, Big Man has been designing and developing high-end Web sites for the past five years. Built on a platform of creativity first, Big Man's company mantra is Everything Is Possible—the staff feels there's nothing they can't do. The design staff at Big Man has grown to work with clients both large and small.

Orange County Teachers Federal Credit Union came to Big Man Creative to redesign its financial institution site. Desiring a more user-centric approach, the client asked Big Man to design a site that fit better with their current print marketing efforts. Their motto, Members First, would factor into the design and development of the new site.

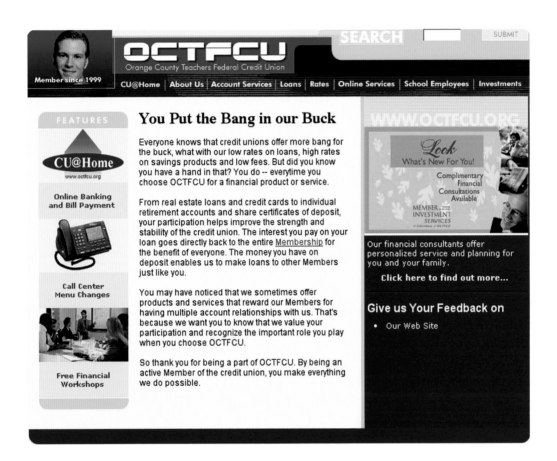

above. The designer's purposeful use of visual space draws users to the areas of the page that contain the most pertinent information. The largest area of the screen is dedicated to that section's content, while the next largest is for related topics.

Usability as a Focus

Usability was an obvious starting place for the team at Big Man, as the current site was extremely difficult to navigate. The overall look and feel was dated and didn't complement any of the credit union's current collateral. "The old site was confusing to navigate," remembers Mumaw, art director for Big Man Creative, "but through a little research and a lot of communication with the client, we found that a majority of people coming to the site were coming to use the CU@Home online banking feature. We felt the design would communicate best if we made the path to that part of the site as easy as possible. The site involved a hierarchy of usage. Our primary objective, outside of a visual overhaul of the interface, was to define this hierarchy and create a logical, usable presentation of information."

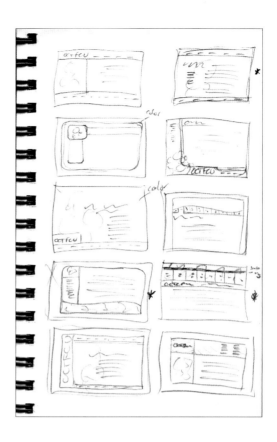

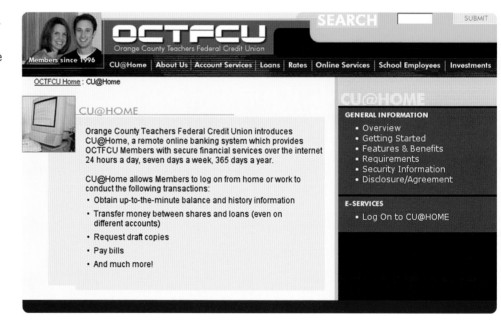

top. Generic design comps help the designers to work through usability issues swiftly by allowing them to move navigation and content areas around the screen quickly.

bottom. Knowing that many users were accustomed to the previous site design, the designers put the search function of the new site at the top. The idea was to alleviate any tension users might feel in confronting the new interface.

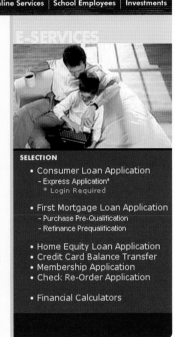

OCTFCU
Orange County Teachers Federal Credit Union

Member since 1992

SEARCH SUBMIT

CU@Home | About Us | Account Services | Loans | Rates | Online Services | School Employees | Investments

OCTFCU Home : Online Applications

ONLINE APPLICATIONS

Our online loan applications allow you to conduct your financial transactions when you want to. Our loan process is quick, easy and best of all, free. So no matter what time of day it is, your credit union is always open online.

Apply for the loan that you need and we'll let you know, in most cases, within hours whether or not you are approved. To assist you, use the Loan Calculators to help calculate an estimated payment that will work best for you.

In addition to our easy, online loan application process, feel free to stop by your nearest branch or call our Telephone Service Center at 714/258-4000 or 800/4OCTFCU (800/462-8328), Monday through Friday, from 7 a.m. to 7 p.m.

If you are currently not a Member of OCTFCU and would like to be in order to take advantage of the many great products and services we offer, apply using our online Membership application. To find out if you are eligible to join, simply refer to the information in our Membership section.

Consumer Loan/Credit Cards Application Process

Applying for a loan is quick, simply:

1. Use the same access code you use for CU@Home, our online banking system, and fill out our Express Loan Application.
2. If you don't already have your CU@Home access code

E-SERVICES

SELECTION

- Consumer Loan Application
 - Express Application*
 * Login Required

- First Mortgage Loan Application
 - Purchase Pre-Qualification
 - Refinance Prequalification

- Home Equity Loan Application
- Credit Card Balance Transfer
- Membership Application
- Check Re-Order Application

- Financial Calculators

above. One of the goals of the project was a more member-friendly interface design, one that included more images of people. A device the designers used to accomplish this was dedicated areas for imaging photography, like the area on the right.

When You Don't Know the Message

Content was a strange creature here. Most of the content existed on the old site, but access to it was limited due to bank security measures. The client decided it would be best to deliver the site design void of content and let the internal technology team at the credit union populate the content. "This approach left us with the unenviable task of creating a site that communicated content we didn't have," stated Mumaw. "Handing over the design template is both a good and bad thing.

It's extremely difficult to design around content that doesn't exist, as the design of the site is intended to communicate or facilitate the communication of a message. On the other hand, there is something freeing about designing in this manner. We relished the creative role, the process of pure design. Although the execution of that design is as much a part of the process as the creative, we still had to build the pages. They were just void of content."

Interface Design as the Primary Communicative Device

With content out of the mix, the design team at Big Man could concentrate on the design of the interface. Simplicity was the guide to creating a site that made searching for and finding desired content as easily as possible. The site navigation had to put destinations in front of users that they were likely to be looking for. "We knew that most people came to the site for the online banking feature," noted Mumaw, "and next was credit union information and account services, so we set up the navigation to make those areas the most obvious on the navigation bar. The search function needed to be enhanced visually to bring attention to its availability, which was not evident on the previous site. We wanted users to feel that they had a wealth—but not an overwealth—of options. We pared the number of original primary navigational destinations from fourteen to eight to create visual space and to avoid overwhelming users with information they probably didn't need."

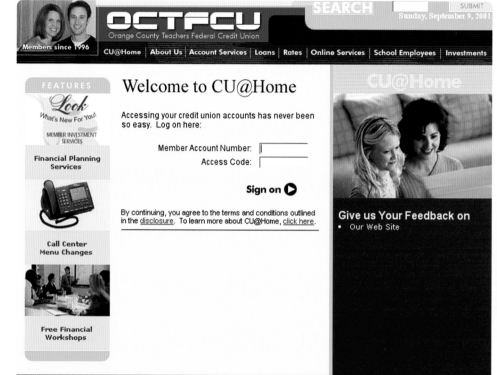

above. The client wanted to dedicate a small area for featured services that could remain constant but not intrusive. The designers used colors similar to those in the content area to create this visual space.

Visually, the previous site used an outdated color scheme. The new collateral materials were from a brighter, more colorful palette, and the client wanted to use this palette online. Big Man's challenge was deciding how best to use this palette. "The credit union's bright, pastel-heavy color palette worked well in print, a medium that can control the appearance of color," teaches Mumaw. "The Web doesn't give that control. A plethora of variables affects the exact representation of color, so we decided to use shades of those colors to create mood. We also felt that it wasn't so much the colors individually but their relationships that really communicated the desired overall feel, so we did our best to use the colors together to create the overall mood."

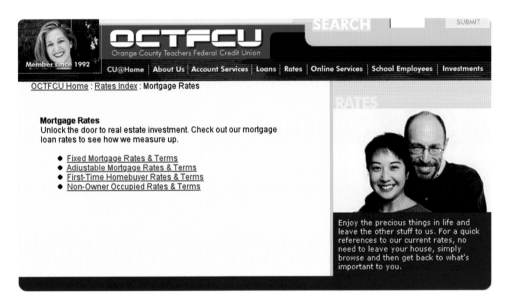

above. To extend the minimalist approach, a rollover subnavigation was used rather than a page filled with subsection links. This way, the client can add services to the navigation bar without redesigning the interface.

The Result

"Our primary goal was to extend the credit union's new brand identity to their Web site," noted Mumaw. "Although not being involved with the content constrained us, to some extent, it also allowed us to concentrate on the usability and interactivity aspects of the site. We could spend our energies on thinking through how people used the previous site, what the target audience would really want in the site, and how the site visually branded the client."

"Visual minimalism is the result of identifying what is essential to be communicated, then delivering it with clarity, restraint, skill, and taste."

Storyboarding the User Experience

villamteden.com

The site for Villa Mt. Eden succeeds in giving users the online experience of being at the winery. The site transitions elegantly from section to section, feeling more like a pausing motion picture than a Web site. The overall consistency throughout the site is remarkable, considering the breadth of information. Organizing and presenting this content in a simple-to-use and elegant way provides the user with an experience that mirrors the sophistication of the winery itself, and the designers have done so without cluttering the page with descriptions and images.

Werkhaus is a high-caliber communications design firm providing a full range of strategic and creative services for marketing and communicating across both print and new media. The company's core values include the constant exploration of how communication design—in all its forms—can be created to help solve problems and to assist in improving the world, not merely adding to its waste. To this end, the firm is developing an emphasis on practicing sustainable design—engineering ideas to be intelligent and to take into account all aspects of their impact on the environment.

Villa Mt. Eden has been creating distinctive wines in the heart of Napa Valley since 1881, and the valley's eleventh bonded winery is one of its oldest producers of premium wines.

"The client wanted to associate a lifestyle with the brand and to entertain the viewer— that was the overriding communication objective," notes design director Steve Barrett, the lead creative on Werkhaus's Villa Mt. Eden project. "The concept was to fuse an entertaining experience with specific product and vineyard information."

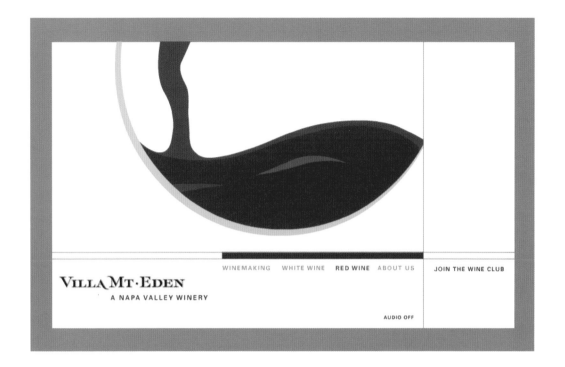

VILLA MT·EDEN
A NAPA VALLEY WINERY

WINEMAKING WHITE WINE **RED WINE** ABOUT US | JOIN THE WINE CLUB

AUDIO OFF

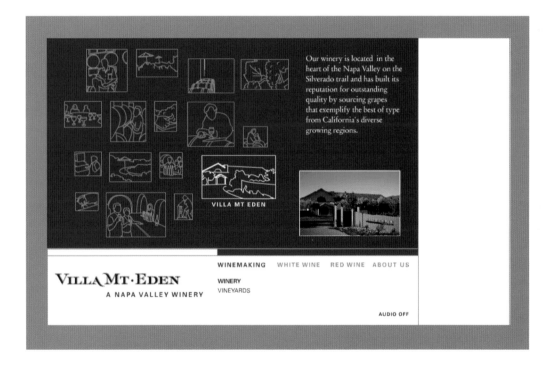

Our winery is located in the heart of the Napa Valley on the Silverado trail and has built its reputation for outstanding quality by sourcing grapes that exemplify the best of type from California's diverse growing regions.

VILLA MT EDEN

VILLA MT·EDEN
A NAPA VALLEY WINERY

WINEMAKING WHITE WINE RED WINE ABOUT US

WINERY
VINEYARDS

AUDIO OFF

top. The relaxing, elegant, animated transition from section to section reinforces the sophistication of the site's subject.

bottom. Using outline tracings as placeholders helps minimize the page size by allowing the user to select which images are to be loaded.

When Volume Takes Visual Form

It was clear at the beginning of the project that the user experience was entirely up to Barrett and his team. Their job included deciding how users would travel through the content. "We decided the best way to achieve the conceptual goal was to categorize the product content by the way you shop for wine—white or red," says Barrett. "As you get closer to a specific bottle, the information becomes more detailed; it moves from a product category description to the awards that a particular vintage has won."

Content presentation was key to the site's ability to communicate cleanly. Barrett's philosophy on simplicity of design—to minimize the amount of messages being communicated at one time—was the foundation of the site's design-related goals. "Too many sites out there are trying to do too many different things and to overcome too many variables," he says. "Everyone is finally realizing that you can't be heard when everyone in the room is talking at the same time at the same volume."

"It is essential to understand the content and what it's there to do. Design delivers the content, so it's vital the two be in harmony. This is probably easier when content is developed after a design direction is clear. When designing around existing content, you need to be able to identify its role."

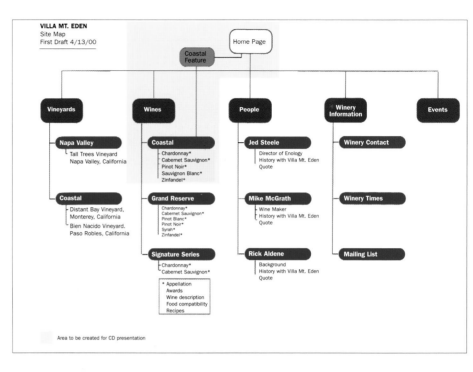

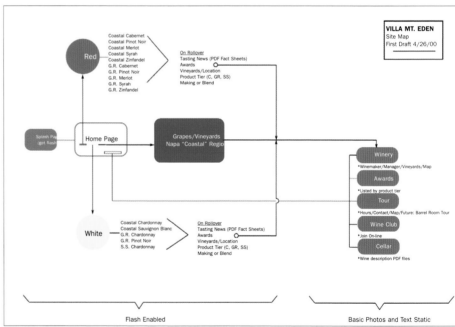

top. The original wireframe detail was more information-driven than the actual site. The site was originally intended to be built in standard HTML only.

bottom. The designers repurposed the original wireframe to include the new navigational direction chosen by the design team as well as the inclusion of Flash production.

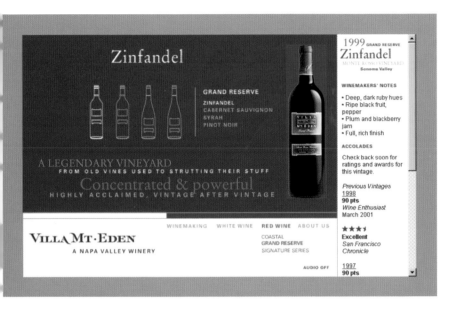

left. The background colors are carried from the subject matter to the navigation, maintaining a streamlined palette and a consistent look.

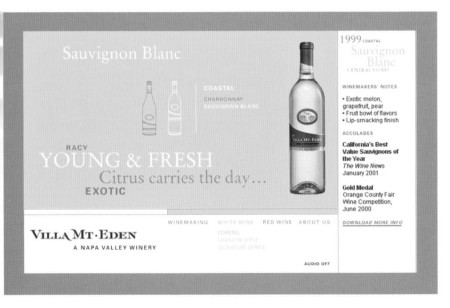

bottom. A combination of Flash and traditional HTML provides a rich branding opportunity with fast-loading information by isolating what changes regularly and using HTML text to communicate those areas.

Rethinking Traditional Methods

Because the site was going to be built with Macromedia Flash, the usual organization methods Barrett and his team used had to give way to storyboards to allow for a more fluid user experience. "We always use a traditional site map to think through and demonstrate the top-level content structure, page relationships, and user paths," says Barrett, "but when working in Flash, traditional site maps are less applicable, so we rely more heavily on storyboards and behavior/motion prototypes. The content relationships were intended to be linked via transitions and motion, so there weren't really pages to map."

"Content was generated and sourced from the client after content organization, page layouts, and word count were clarified and agreed upon. After the site evolved and certain areas were revised for better functionality, some content was retrofitted to suit the revisions."

Many times, the original site outline may need to change as either the client or the designer sees a need to focus the message elsewhere.

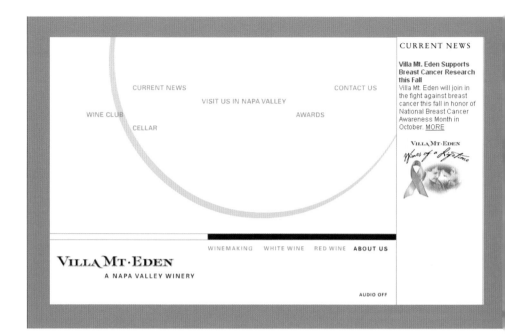

It's important to create these site map drafts in such a way as to allow room for flexibility as design gets under way. Barrett's team stayed on track by first creating a defined set of project objectives, then designing for the overall picture, and finally aligning the design with the objectives. "We make an attempt to educate the client on our process, and its value, up front," says Barrett. "The key thing is to reach consensus on the communication objectives. It's then helpful to refer to those objectives throughout the development of the site, with the understanding that they may need to change as we work."

"We design around those communication objectives, then we refine or distill the design down to a form that works within the technical specs. We look for design clues and inspiration in the content the client brings to the table."

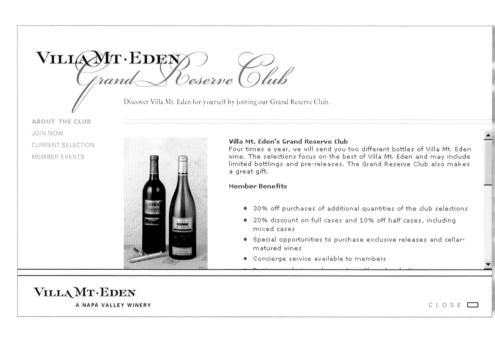

top. The traditional HTML part of the site allows the winery to update current news quickly without interrupting the design.

bottom. The entire "About Us" section opens to a sized window to present HTML-only versions of content that is meant to be considerably more informational than the educational goals of the Flash site. This method allows users to get needed information quickly and also enables users to copy or print the information for other purposes.

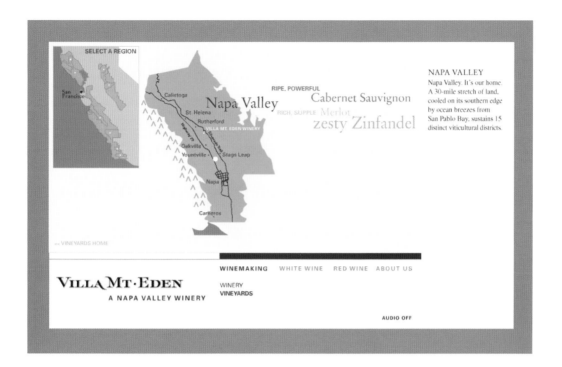

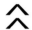

above. The consistent use of the border and white space helps set the appropriate relaxed mood and allows the designers the freedom to use a variety of illustrations seamlessly.

The Result

The use of line art wireframes as placeholders for bottles and images gives the site an airy, open feel, a characteristic important to the site's success. It certainly helped that the client relied on Barrett and his team to decide what content would be used in the site. "Because we had the opportunity to create the job description for the content, our storyboards were used by the client/writer to develop copy and gather images," says Barrett. This close-knit interaction allowed the designers to create a compelling and informative site.

Nothing was left to chance. Simple navigation adds to the minimalist approach and provides the lighted path along the user's journey through the site. "A sense of intentional navigation is critical," says Barrett. "Navigation is as important as everything else that communicates on a site. Effective navigation design has everything to do with the impression that users will have with the site. Whether it's good or bad, simple or cryptic, obscure or intuitive, navigation always communicates something. It should be seen as a powerful communication tool."

"Visual minimalism is a fusing of the classical and romantic approaches to design, where intuition and knowledge play equal parts."

Purposeful Content

howitworks.com

The How It Works site is a beautifully clean and focused work that provides pertinent information to users as well as showcasing the How It Works design philosophy. Using color and negative space to keep the site simple, the designers have created a site that is easy to navigate and attractive to view.

How It Works is a talented group of media professionals with years of experience creating for the Internet, print, television, and radio. Founder Chris Terrell started How It Works in 1994 after recognizing the need for affordable, high-quality media design in his local area.

The firm's goal for its own Web site was the same as for almost every other Web design firm's site—to provide information and show capabilities. Most design firms emphasize capabilities, loading the site with every bit of technology they have the skills to produce, but the designers at How It Works saw their situation differently. "The purpose and goal was to create a Web site that represented the essence of our design firm in a professional and informative manner," says Terrell. "We decided that the best way to achieve this goal would be through a clean and intelligible interface."

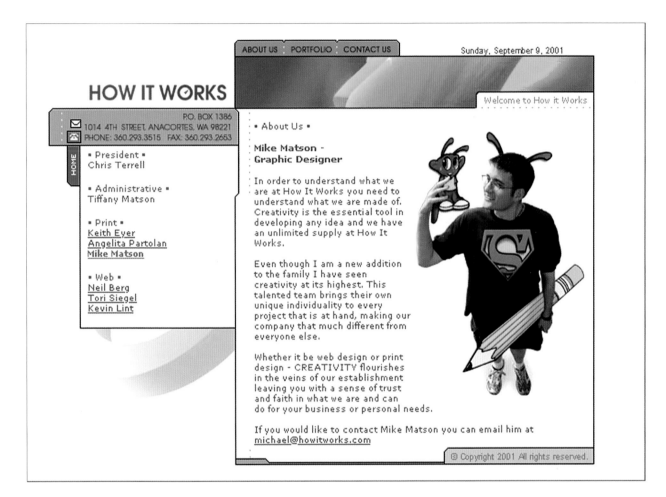

HOW IT WORKS

ABOUT US | PORTFOLIO | CONTACT US

Sunday, September 9, 2001

Welcome to How it Works

P.O. BOX 1386
1014 4TH STREET, ANACORTES, WA 98221
PHONE: 360.293.3515 FAX: 360.293.2653

• President •
Chris Terrell

• Administrative •
Tiffany Matson

• Print •
Keith Eyer
Angelita Partolan
Mike Matson

• Web •
Neil Berg
Tori Siegel
Kevin Lint

• About Us •

Mike Matson -
Graphic Designer

In order to understand what we
are at How It Works you need to
understand what we are made of.
Creativity is the essential tool in
developing any idea and we have
an unlimited supply at How It
Works.

Even though I am a new addition
to the family I have seen
creativity at its highest. This
talented team brings their own
unique individuality to every
project that is at hand, making our
company that much different from
everyone else.

Whether it be web design or print
design - CREATIVITY flourishes
in the veins of our establishment
leaving you with a sense of trust
and faith in what we are and can
do for your business or personal needs.

If you would like to contact Mike Matson you can email him at
michael@howitworks.com

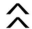

above. Just a splash of color is all that
was needed to define the structure of
the page. Any more would have looked
forced and would have distracted from
the message.

Guiding the User's Eye

The direction of the design illustrated Terrell's philosophy in action. "Many characteristics of a visually minimalist design can increase the quality of the user's experience," he says. "Web sites that contain large amounts of information need an organized way to lead users to the content they wish to view. Information that appeals to a particular user's interests can be easily overlooked in the visual clutter of a busy page. Through visual minimalism, the designer can guide the user's eye. The user thus can locate desired information with less effort and less confusion. Designers utilize the advantages of a visually minimalist approach as they recognize the need for clarity and structure within an interface."

Lack of Personal Organization

A strange phenomenon that often occurs when design firms work on their own sites is a lack of organization at the beginning of the process. Most designers feel they are so familiar with the content that it would be too time-consuming to follow traditional process. The How It Works site, however, expresses a purposeful and deliberate organizational pattern led by clear-cut goals and specific responsibilities. "Once a global objective was established," says Terrell, "we created a site map, discussed overall page layout, then reached a design consensus concerning how a proposed interface might meet our criteria and objectives. We established the sections, what kind and how much information each section would contain, and how we could articulately organize valuable information within each section while avoiding redundancy."

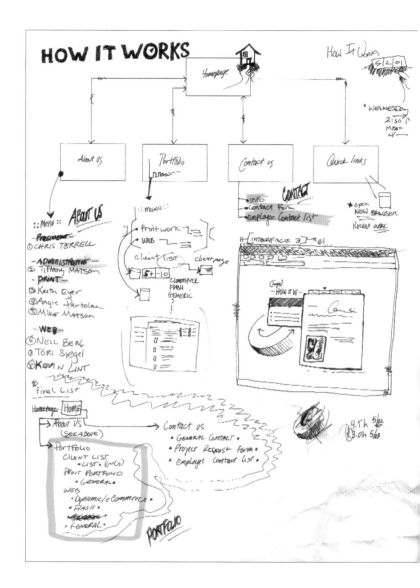

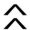

above. Even informal, sketchbook-driven, wireframe organizational practices can allow the designer to work out thoughtful navigation and content presentation.

Purpose throughout

Not only does the How It Works site have a specific purpose, so does each section. "The purpose of the About Us section," Terrell says, "is to familiarize and connect viewers with How It Works and its employees by providing insightful information on each designer and his or her talents. Communicating the individual information adds a personal feel to the site and can be the deciding factor in building new relationships with potential clients who might have skipped this key section because of visual overload.

"The purpose of the Portfolio section is to create a platform that logically and efficiently exhibits our work while providing visitors with useful information. We categorized each medium, allowing users to view a variety of examples and see our technical and artistic proficiency firsthand. In this structure, users are able to observe the diversity of our clients, our technical capabilities, and our artistic skill on a wide variety of projects, all within view of the browser."

"The purpose of the Contact section is to provide specific contact information for each staff member, as opposed to generic contact information. We incorporated a simple contact form that users can fill out online. This format allows both general and specific questions to be answered directly."

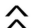

above. To keep the content as clean as possible, the designers used a legend metaphor to communicate the services rendered for each project.

Everything for a Reason

The remainder of the site development process is a perfect example of how to organize and produce a Web site. Every design decision the designers chose to make had purpose and function, not just design for design's sake. "After establishing a concept, a site map, and a layout approach," Terrell says, "our next logical step was to create a look and feel. To skillfully present our work, we aimed for a balance between clarity and visual interest. The objective of the designers was to create a visually minimalist interface that provided simple navigation while utilizing several visual techniques to direct the attention of viewers toward the subject without the interference of unneeded, flashy eye candy."

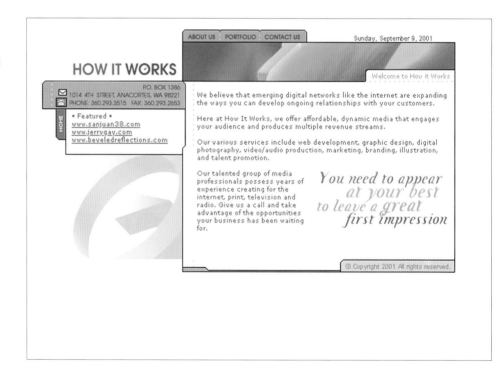

top. Within the Portfolio section, the designers felt that a tertiary navigation would cramp the portfolio pieces. Instead, they used a next/back button functionality along with a thumbnails page.

bottom. Using simple shapes and lines, the site content is reduced to a small space, but that space is more than enough to communicate the core message.

"The resulting navigational approach allows users to move easily throughout the site while retaining the ability to funnel down to a specific piece of information within a category. With each successive click, the title of the category/subcategory is the first text to be read within the document body. It is followed by a concise paragraph pertaining to the category/subcategory. Each sequential step provides useful and relative information to the user, who thus can visually trace his or her steps. The interface remains a fixed width of 600 pixels and is centered within the window to utilize the white space provided by the target audience's selective monitor resolution. This approach offers a clean feel to the interface and brings the eye to the center of the monitor, where the body of the interface is positioned. The site design is composed of thin lines and a relatively soft and simple color palette. This is consistent with our company's branding scheme."

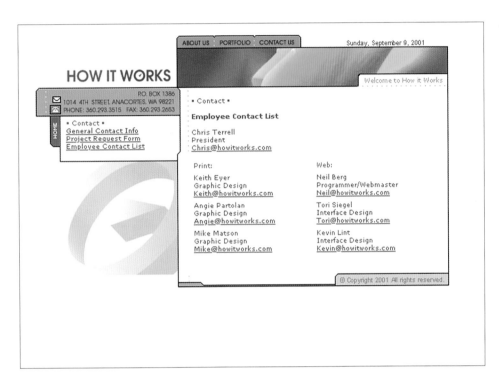

above. The subnavigation for the sections appears on the left, away from the small content area and displaying simple, elegant text links.

The Result

The site's simplicity of use and visually thoughtful interface create a delightful user experience. "Simplicity is achieved through the use of space and the elements within that space," says Terrell. "Visual minimalism is guiding the eye through the content. Displaying the content in a clean and artistic manner requires a well-thought-out process that can be difficult to achieve. In the words of Antoine de Saint-Exupéry: A designer knows he has achieved perfection not when there is nothing left to add but when there is nothing left to take away."

"Simplicity is avoiding distraction. Design should not distract from content but should support it."

Highlighting Strong Content

johncoltrane.com

The John Coltrane site uses muted colors; clean, crisp lines; and subtle animation to create an environment that works to mirror the sophisticated tone in the work of a jazz legend. The rectangular layout provides ample room for content as well as blank space and uses a structured grid to present content. The gray-blue color provides a stage on which to present this content. By designing the environment as neutrally as possible, the designers have ensured the focus of the site will not be on the wrapping, but the gift.

Juergen Bauer and Llewellen Heili founded Automat in 1999. Located in Vienna, Austria, Automat is an independent project, shifting between all forms of media productions.

The John Coltrane Foundation was established to provide scholarships to outstanding young musicians and to create venues for these young artists to perform. The site is a promotional and informational portal for interests related to John Coltrane.

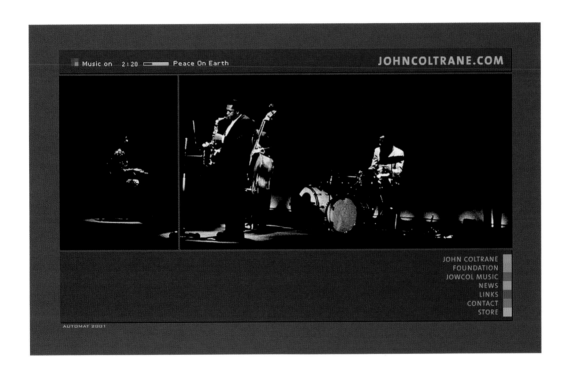

above. The framework of the site design provides an optimal content area to focus the user's attention on the subject matter.

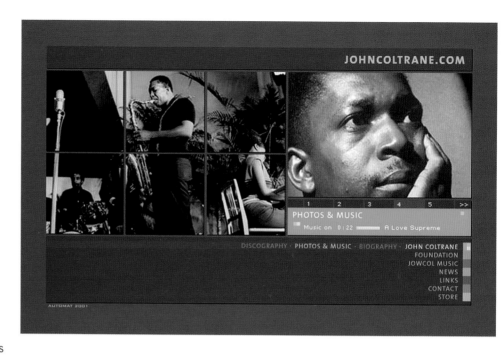

Letting the Content Be the Hero

It was clear to the designers that the content of the site, not the site itself, was to be the focus, so they set the wheels in motion to create a site that was truly and completely about the subject at hand. "The only requirements of the project were to produce a site that embodies the life and music of John Coltrane," remembers Bauer. "In terms of visual design, it was important to us to reduce design elements to a minimum so that we could center on the artist's achievements by means of music and images. Our goal for the visual and conceptual approach was to combine design, functionality, and content into a cohesive unit."

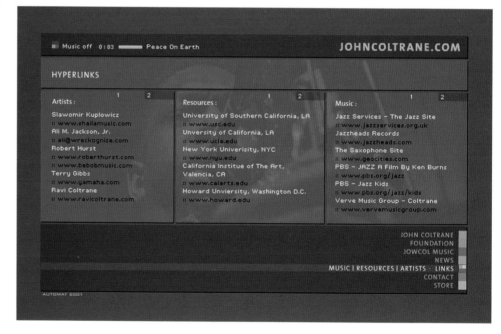

top. The designers chose to create square and rectangular content areas for the image gallery, allowing them to include as much visual imagery as possible into the design without the user feeling overwhelmed with individual pictures.

bottom. By separating the links' subjects into their respective categories, the designers not only avoided any scrolling issues that would have come with a long list of content, but they created a visually simple presentation of a great deal of text content.

above. Separate color schemes help reinforce each section, giving users added comfort in knowing where they currently are in the site.

Hitting the Spot With the Design

The designers were intent on creating an interface that was both intuitive and transparent, something that could be used to contain and navigate the site but was not the focus. They felt the site had to be, at its best, simple to use. "The nature of simplicity lies in the art of hitting the spot," teaches Bauer. "Reducing everything down to its bottom line is conveying visual minimalism. We don't think that specific colors or forms are responsible for minimalism; it's more about the use and combination of design elements."

"Everything that could distract should be avoided. We prefer clear sequences, visualizing functions—which normally are not shown at all or are hidden in the background. The John Coltrane site conveys its simple character by using and working with the provided material and with the phenomena of John Coltrane himself. This great jazz musician does not need anything else to make him or his work attractive. The show is the content itself. There was no need to make up additional attractions."

right. The subnavigation on the section pages is intended to stay out of the way of the design yet provide ample navigation to move around a particular section.

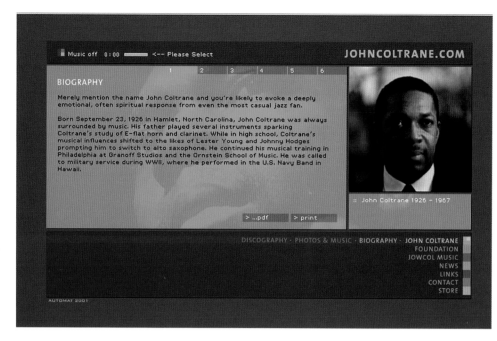

Keeping Navigation Apart Visually

The site is extensive, with many destinations. It was apparent to the designers that how they presented the navigation was going to be a challenge. They wanted to give the user the ability to navigate easily around the site, but they didn't want the navigation to be a centerpiece visually. "We wanted to keep it simple, clear, and comprehensible," states Bauer. "Our intention was to turn the users' attention to John Coltrane and the foundation and not to distract from it. We wanted to create something harmonizing and coherent. Therefore, the navigation structure is simple and open. The color guidance system functions as an information guide telling the user which section he or she currently is in."

The designers at Automat feel very strongly about the importance of effective yet visually appropriate navigation design. "Communication design is navigation design," notes Bauer. "Without navigation you would not have effective communication. The simpler and more concise the navigation is, the more quickly you get the information and content you are looking for. Not only can navigation communicate content, but it can turn into atmosphere and expression itself."

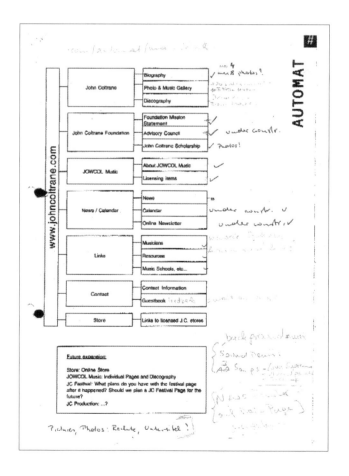

above. The site map wireframe provides the overview of the site to the designers, a step that ensures the focus of the site is not lost.

Using Interface Design to Set a Mood

John Coltrane's music is, to some, the personification of emotion, using musical notes to speak to the soul. An important goal of the designers was that the site be evocative of this mood. The designers would have to accomplish this through imagery, music, and animation. There is an innate simplicity to jazz as a musical style—the notes are clean and deliberate, and few jazz musicians have expressed this simplicity quite like John Coltrane. The site dedicated to his work is best served by mimicking this artistic simplicity.

"The John Coltrane Foundation provided the raw assets," recalls Bauer. "We made suggestions on how we would like to transport the spirit and mood via imagery and music. The client was trusting enough to give us total artistic freedom to choose the photos and music and produce them in a way that we thought would create the most appropriate atmosphere and comfort."

"Musically, we thought a dual audio tool would be perfect for the site, so that the user has option to listen to as much or as little music as they wish. Visiting the site allows users to be surrounded by John Coltrane's music if they wish. In the specific music and photo section, users find a far greater selection of works and can dive into John Coltrane's sensuous music."

above. By using a complementary rectangular theme for the content area, the designers could carry the overall design layout, along with its design philosophy, into the site.

The Result

The site allows the user's complete attention to focus on the content, not the site design. It accomplishes this by setting the mood of the subject matter, then allowing the content to be the focus. Not only do the music and imagery reinforce the site's focused subject, but the soft, subtle animation techniques create a visually interesting mood, providing appropriately slow and deliberate transitions from section to section.

This attention to the importance of the content was deliberate. "Content and design always go hand in hand," states Bauer. "Although the type of content and intention of the site vary, the design should always support the message of the Web site. In our point of view, it would be counterproductive to release a Web site where content and design would not fit together."

using design principles to encourage visual minimalism

Designers are trained to recognize patterns in communication; they are expected to know the best way to reach the intended audience and are compensated for that understanding. They follow design principles that allow them to control the intake of information—what's read or seen first, what message is conveyed, and when it is conveyed. Designers also use visual tools—color, shape, size, and layout—to communicate order, emotion, mood, and attraction. These elements allow designers to design and create simple structures from complex assets. In short, designers can make a lot look like a little. They do that by applying not only what they know but what they've experienced. Simplicity is rarely the result of too little to say, but rather, how it is said.

The sites within this chapter represent design principles in action. These sites use methods of shape and size to focus the user on the message and not the design. They use color and layout to organize the message and provide the user with the information in a timely and understandable manner. Simply put, a picture is worth a thousand words.

> "Visual minimalism gives users time to access the high-level message while pulling them into the deeper, more meaningful message."

// DESIGN FIRM: **New Tilt** / PRINCIPALS: **Ross Morrison, Michelle Chambers,** and **Carri Mullaney**

Working with an Abbreviated Time Frame

newtilt.com

Featuring an inventive primary navigational scheme, the New Tilt site flows effortlessly from section to section. The navigation is so intuitive and complete, it doesn't take long to actually get to all of the content on the site. This ease of navigation affords the designer the ability to create an interface void of dedicated navigation areas that most other sites must include in the design.

New Tilt is a strategic experience design company that offers online branding, information architecture, and user interface design services. The members of the New Tilt team have been designing interactive software projects since the 1980s—long before the World Wide Web existed. While working at high-technology corporations, team members helped define the online information-design methodology currently used by Web designers. This methodology focuses on the importance of usability, provides a user interface defined by user needs, and results in a solid information architecture that grows as new needs arise.

The New Tilt Web site was designed as the primary marketing tool of the newly formed company. Making it available to prospective clients was paramount to the success of the studio. "At New Tilt, we've seen our share of short—even sinister—deadlines," says Ross Morrison, founder of New Tilt. "But there was never a deadline more daring than the one we placed on ourselves. We had just joined together to start a company, and we needed a Web presence as soon as possible. It was daunting to call on potential clients until we could refer them to our identity online. After settling our base corporate identity through a logo design, we gave ourselves around three weeks to get the entire site up and functioning."

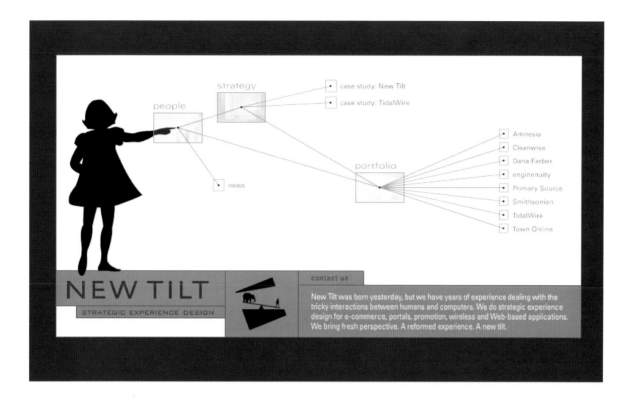

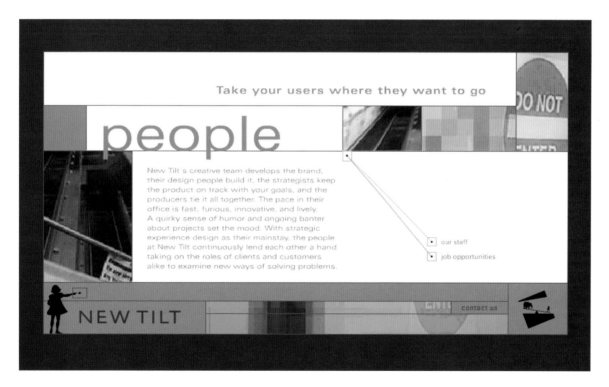

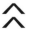 **top.** The key element throughout the entire site is the unexpected and wonderfully conceived navigational function. Each box includes a moving image that comes to life when the user rolls over it.

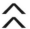 **bottom.** The visual elements of the navigation are carried through to subnavigation areas throughout the site, offering easy navigation and interesting design elements.

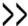

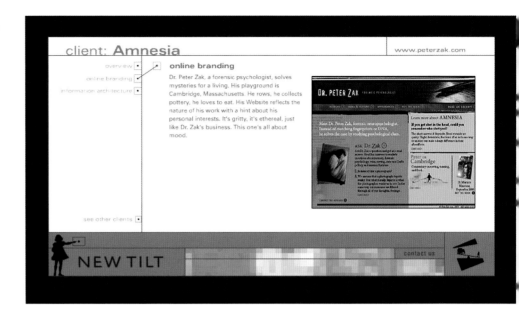

right. Each of the portfolio selections is broken apart to describe exactly what New Tilt accomplished for the client. This provides the user with quickly understandable information.

Knowing Your Process

This site design was to act not only as an example of what they were capable of accomplishing but would also serve as an internal test of their own development process. "We started with an information architecture and several visual directions," recalls Morrison, "one of which was quickly chosen. Because of our time-to-market constraints, we skipped the wireframing step and opted to work straight from the information architecture. Content was matched to the pockets of information, and we established a character count for every page. This was important to the design process because we planned to build the entire site using Macromedia Flash and scrolling would not be allowed. We had to know exactly how much space we could allow for content. The actual content was written, reviewed, and edited parallel to creating the site. Only in the last hour before launch was the final content added. It fit perfectly."

Thought-Provoking Imagery

The overall layout and design of the site support New Tilt's corporate creed that messages need to be clear and simple without the usual industry jargon. Clean, crisp imagery and short, focused copy reflect this philosophy. With an abbreviated deadline looming, the team had to make decisions fast. "While the content was being written, we jumped right into designing the look and feel of the site," says Carri Mullaney, creative director and cofounder. "The writers agreed to keep to a word count dictated by the visual design, a decision that also required minimalist writing. This supported our overall design philosophy."

"New Tilt designs user experiences," adds Michelle Chambers, president and cofounder. "Philosophically, we believe that a design should exactly match the goals of the communication. Here, we chose a minimalist approach because we wanted to get our message across clearly and quickly. We didn't want any of our users (all of whom are potential clients) to get bogged down in too many words or too many pieces of information. We wanted users to understand what we are all about as soon as the homepage loads."

"To enhance the minimalism of the branding and architecture, we also seek to intellectually provoke our users. What does the image of the girl mean? What is the logo trying to say? An elephant? A seesaw? These simple images suggest to users that something more is going on here than meets the eye. The visual minimalism gives users time to access the high-level message while pulling them into the deeper, more meaningful message."

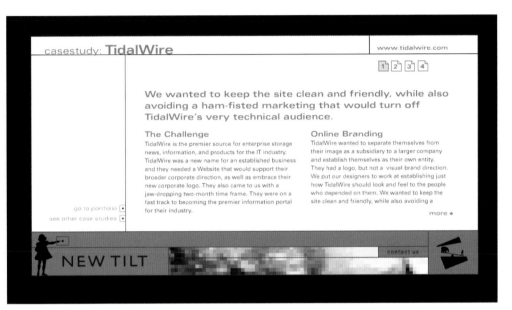

casestudy: **TidalWire**

www.tidalwire.com

1 2 3 4

We wanted to keep the site clean and friendly, while also avoiding a ham-fisted marketing that would turn off TidalWire's very technical audience.

The Challenge

TidalWire is the premier source for enterprise storage news, information, and products for the IT industry. TidalWire was a new name for an established business and they needed a Website that would support their broader corporate direction, as well as embrace their new corporate logo. They also came to us with a jaw-dropping two-month time frame. They were on a fast track to becoming the premier information portal for their industry.

Online Branding

TidalWire wanted to separate themselves from their image as a subsidiary to a larger company and establish themselves as their own entity. They had a logo, but not a visual brand direction. We put our designers to work at establishing just how TidalWire should look and feel to the people who depended on them. We wanted to keep the site clean and friendly, while also avoiding a

more ◆

go to portfolio •
see other case studies •

NEW TILT contact us

left. The typographical treatment, which mirrors the simple, straight-lined style of the design, is carried throughout the site.

69

» http://www.newtilt.com = SIMPLE WEB SITES

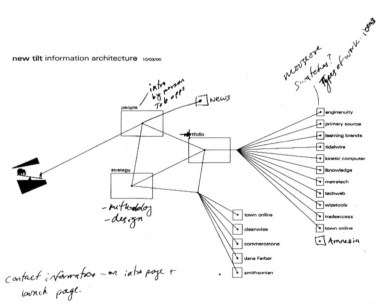

above. The designers needed to gather their thoughts on the overall direction of the content. The result is as clean and simple as an initial wireframe can be.

Those Blasted Deadlines

The development process was necessarily an abbreviated version of their preferred approach. The New Tilt team had to rely on their understanding of the content as well as their ability to organize and simplify their thoughts. "The New Tilt Web site was a little different for us because it was an internal project and the timeframe was abbreviated," says Mullaney. "We were interested in getting our Web presence established as soon as possible. We felt that, as an interactive design company, the Web site would drive our overall branding."

"The site was designed and developed in two phases. The first phase took approximately two weeks. We did a lot of brainstorming initially about what was important for the New Tilt message and what elements would best support that message. Once that was clear, we developed an information architecture. We decided we didn't want the information to reflect a strong hierarchy and talked about how we could show a flat architecture in the simplest way. The actual architectural diagram that was drafted ended up being represented on the site in the treelike structure of the navigation."

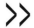

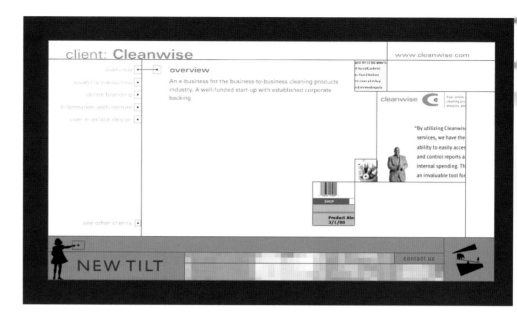

right. The home page of the individual portfolio selection uses thin lines and detailed images of the work to briefly explain who the client is.

Rethinking Traditional Navigation

It's often difficult for designers to both express their own design philosophy and present the breadth of capabilities they possess. The New Tilt staff found a distinctive way to do both. "In any interactive communication, easy-to-use and appropriate navigation is at the heart of effective design," says Chambers. "Because the New Tilt Web site is a self-promotion marketing vehicle, we wanted to express our intellectual process as well as our capabilities. We went so far as to integrate the idea of navigation into the branding and the information architecture of the Web site to show how pivotal it is in the designing of interactive communication."

To the New Tilt team, navigation is never treated as an afterthought. It is addressed from the beginning of the development process. "Information architecture is the navigational blueprint for an interactive experience," says Chambers.

"Without a well-thought-out, clear navigational scheme, an interactive design is simply eye candy and not a meaningful user experience. Real interaction means giving users a clear sense of navigation so they can uncover the desired information or accomplish the tasks required to successfully complete the desired action."

The navigational layout for the site expands visually across the page as a section is chosen. "The online brand for the New Tilt Web site uses a traditional drawing of a navigational scheme that unfolds across the page. This way we not only illustrate the relationships of the materials within the Web site but also show the simple thinking behind how an easy navigational system can expand."

above. The designers decided to use the wireframe production graphic as the actual navigation for the site.

Designing Sentences

While many designers create holders or attractive frames for client content, New Tilt is interested in molding the content itself to further the brand identity they've created with the design of the site. This approach requires more time and more effort, but the result is a site that completely encompasses a company's message, from imagery and layout through copy and content. "Content was a significant focus for the design of the Web site," notes Chambers. "New Tilt is a fairly new company founded by a group of people who have a lot of experience designing easy-to-use Web sites. We wanted to show our expertise while emphasizing our new approach—that is, a new tilt to interactive design."

"We used the content as an integral part of the online brand because we wanted to emphasize the strength we bring to a client relationship—people, strategy, and portfolio. The tone of the content further emphasizes the New Tilt brand because of its staccato rhythm and smart language. The content development was designed in concert with the online branding and the information architecture. As it does for most of our clients, the creation of the Web site content served as our company's positioning exercise."

"We wanted to present an attitude with the content. We wanted to be crisp and clear. We didn't want to be clichéd or long-winded. We wanted the content style to reflect our style—smart, fast, and new."

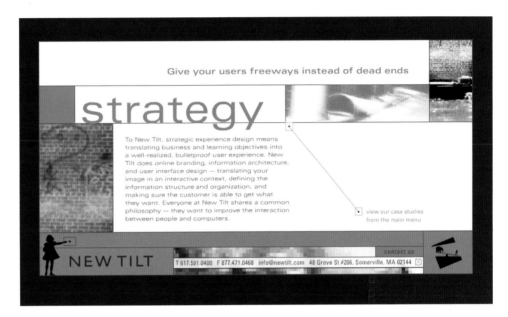

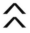

above. Contact information is the piece of information design firms most want to publicize, so New Tilt placed theirs at the bottom of every page.

The Result

The resulting site achieves its goals on every level, but especially in the user experience arena. "We are evangelical about what is now being referred to in the industry as *experience design*," says Chambers. "Experience design is the deliberate combination of graphic design, interface design, information architecture, technology, and marketing as well as, in an increasing number of cases, industrial design."

"In our case, you can't separate the brand from the information architecture, as they are deliberately integrated to emphasize the point that experience design is at the heart of successful communication."

> "Often it's not the content itself but access to the content that causes visual clutter."

// DESIGN FIRM: **DigitalDay** / DESIGNERS: **Teresa Kiplinger** and **Jeff Kahooilihala**

Hundreds of Items Organized into One Clean Design

arhaus.com

The site is a beautiful combination of elegant design and warm, inviting photography. The curved bottom provides subtle visual unity while the effective use of negative space draws viewers into the site.

Creating for the Web since 1995, Teresa Kiplinger and Jeff Kahooilihala possess an uncommon understanding of interactive design. Their experience in visual design, illustration, authoring, and programming enable them to envision as well as execute their concepts. Their rare talents blend in interactive works that are at once technically eloquent and aesthetically striking. Kiplinger and Kahooilihala are currently design directors at DigitalDay.

Arhaus specializes in the design and manufacture of exclusive, high-end furniture and has a retail presence throughout the Midwest. Arhaus asked DigitalDay to design and develop a site to promote brand awareness and drive traffic to the retail stores. DigitalDay proposed a visually simple design treatment that reflects the in-store environment and overall aesthetic of Arhaus's products. "Because of the nature of their business, Arhaus shares our appreciation of aesthetics and visual elegance, so the client was easily convinced to go with a simple visual treatment," says Kiplinger, the primary design director for the Arhaus.com project. "An elegant aesthetic is evident in Arhaus's products and retail environment, so we felt it was a natural progression to carry this aesthetic to its Web presence. We spent as much time in the stores and studying Arhaus's sales and buying philosophy as we did assessing their content."

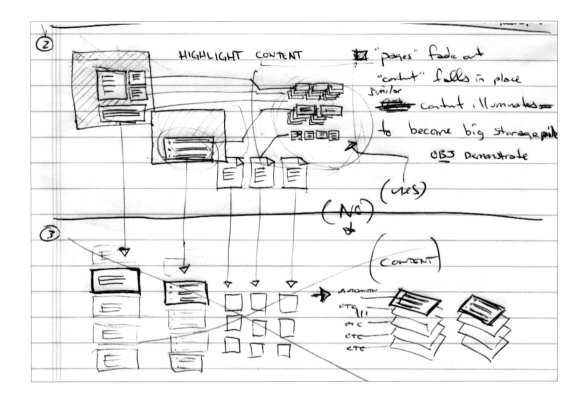

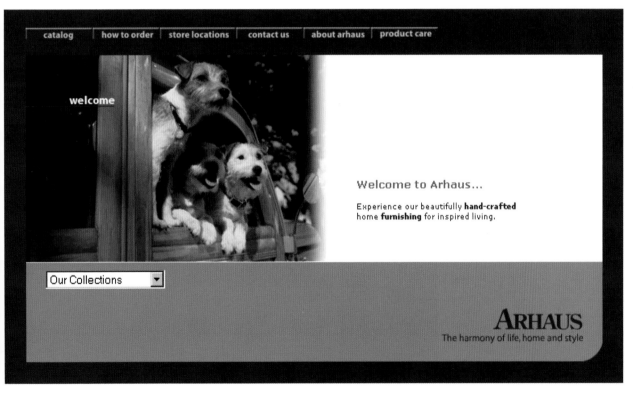

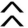

top. These notes are both a wireframe for organizational purposes as well as the beginning of the content presentation design the site would feature.

bottom. The imagery on the opening page is distinctive in that it doesn't represent the product itself; rather, it's an emotional expression of a lifestyle represented by the type of furniture Arhaus creates and sells.

Content Is King

The challenges with the Arhaus site were time and organization. "Because the project was on a tight turnaround," Kiplinger says, "we had to move forward with the designs before a complete content inventory had been made. We worked closely with the client to determine sample content and get a general headcount of items and product information."

Meaningful content organization was vital to the success of the site, as it would be for any large site. "Normally we rely on a combination of wireframes and site maps to develop our large Web sites," Kiplinger says. "These tools provide a means of communicating architectural strategy and basic layout to the client as well as to HTML producers and programmers. Arhaus, however, was an unusual project. The site was produced entirely by two designers from concept and project management to programming and design." This approach allowed the designers to carry their vision to completion without having to create the otherwise necessary formal wireframe to communicate to the technical staff. "We were able to maintain complete control over every pixel and piece of code that went into the build, and this afforded us a unique flexibility within a normally rigid process."

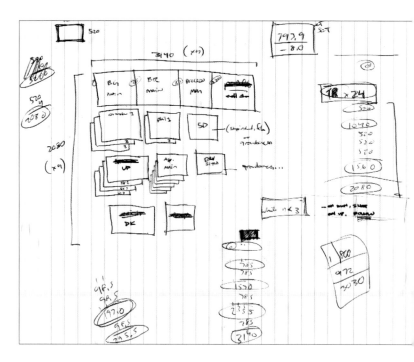

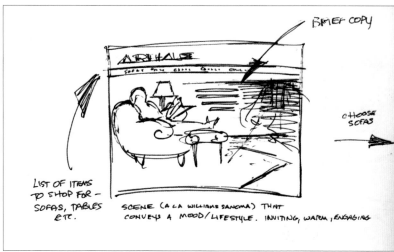

top. Simple wireframe notes at the beginning of the project can help clarify the navigation when the organization of the content gets complicated.

bottom. This sketch is noteworthy less for the image than for the comments that state "scene that conveys a mood/lifestyle." As long as the designers didn't stray from the concept, the design could evolve and communicate effectively.

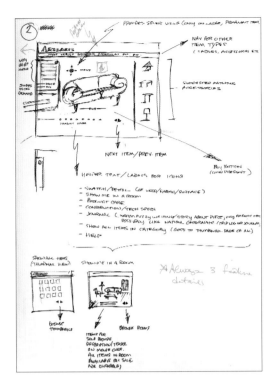

left. These site design notes are the building blocks of the final navigation.

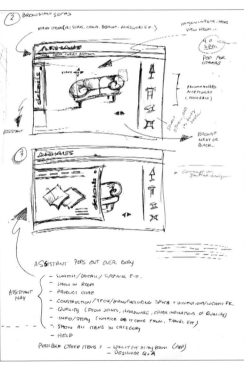

Good Site Architecture Leads to a Good Design Foundation

As is evident by the sketches, the site's basic structure underwent little change in layout but extensive evolution in the presentation of content. The designers' approach to this project afforded them the flexibility to explore various content presentation designs during the comping and production process. "Throughout the production, we relied on simple sketches, constant communication, and a fluid process of collaboration and experimentation rather than wireframes and site maps," says Kiplinger. "We believe that if we had produced extensive wireframes and maps for this project, we would not have sustained the flexibility that enabled us to arrive at such a successful, simple design treatment."

Navigation can make or break effective communication in a site this large. To Kiplinger and Kahooilihala, the success of the project relied heavily on the user's ability to navigate this mass amount of content. This concept has become more than just a project-specific goal; it has become a Web design principle at DigitalDay. "The site architecture and navigation should be designed and driven by the business objectives of the client and the nature of their audience," Kiplinger says. "Once these points are determined, the role of design is simply to organize and present the navigation in a way that is intuitive and clear to the user." Realizing that pages of copy or overabundant navigation would disrupt the simple aesthetic pleasures of browsing through products, Arhaus agreed to allow simpler navigational design and less content in exchange for a stronger overall image.

above. The designer's notes at the bottom list possible sections to include in the Web site. These brainstorming exercises are not only a valuable service to the client but are an important step in planning the overall site.

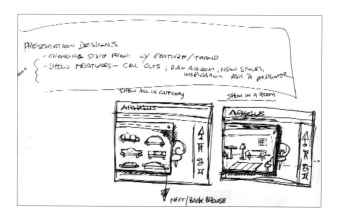

right. This sketch illustrates how much the site design evolved from the original yet how accurate the notes still are in relation to the current design.

Content Presentation Becomes the Primary Design Objective

During content-management development, time concerns and overall aesthetic value created a need for constant collaboration between Arhaus and DigitalDay. General design direction in hand, the designers began the process of presenting content. Conceptually strong design principles provided both designers and client with a light for the journey. "We try never to assume that the content of any project can yield to a design," Kiplinger says. "We consider the client's brand and business objectives, the audience and technical requirements, then suggest solutions for the visual presentation of the content. Arhaus describes its vision of retail as theater. Knowing this, we proposed a nontraditional treatment that would create an online atmosphere like that of the retail presence. With this concept in mind, we worked together to sort and prioritize the content."

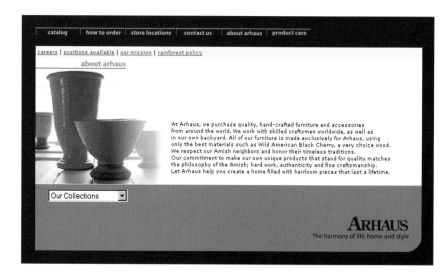

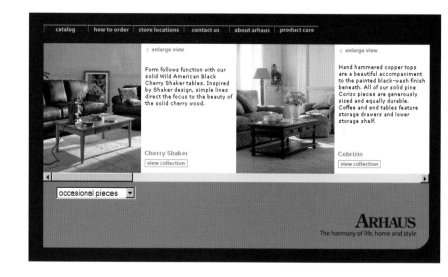

top. By beginning the content halfway down the page, the design maintains a spatially attractive balance.

bottom. A horizontal scrolling technique allows the designers to include large amounts of content without disturbing the design. Notice how unobtrusive the scroll bar becomes within the design.

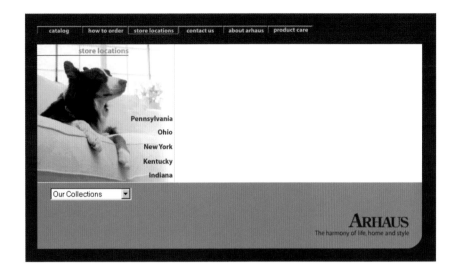

"We believe that any content can be effectively organized and designed, as long as the site's objectives and audience are clearly understood. Our challenge with the Arhaus site was to accommodate hundreds of products in several categories while maintaining a simple overall visual tone. Often it's not the content itself but access to the content that causes visual clutter. Intending to create an intuitive experience, we designed the site's navigation so that users can call or dismiss it when they choose and arrange it on the page to suit their browsing style. This helps create a sense of viewing a few products in an intimate environment when in fact the site contains hundreds of items. We did not achieve this by design alone; the Flash programming in this site is every bit as elegant as the design, and the effectiveness of one could not exist without the other. Combining Flash with a thoughtful design enabled us to creatively control the presentation of the content in a way that avoids clutter and information overload."

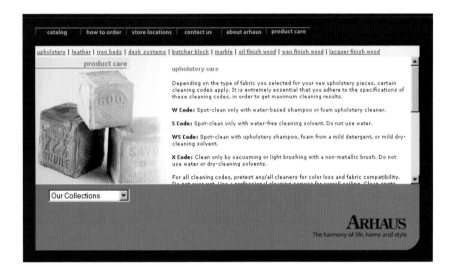

top. Leaving content out of areas that don't need it can create visual breathing room.

bottom. The color gradation from the image on the left to white allows the content on the page to scroll without disturbing the other elements. It also provides a naturally comfortable transition from the image to the content.

The Result

The minimalist approach the designers took in presenting product content is commonly a tough sell with relatively conservative clients. "Almost every project is as much about educating the client as the work itself—we find effective design dialog and communication is as important as the finished product," says Kiplinger. "We feel it's our role to advise clients against decisions that will dilute the design or adversely effect the user experience."

"To result in a positive user experience, the designer must present the interface in such a way that the end user knows what to do, where to go, and how to find information."

Using Navigation as the Primary Design Element

axiomstudio.com

The Axiom Studio site uses white space and clean, crisp, gridlike layouts to convey a focused, simple message. The sparse use of branding imagery keeps the viewer focused on the core message.

Michael McDonald, chief creative officer for Axiom Studio of Philadelphia, Pennsylvania, is committed to delivering compelling design to define and enhance his clients' brands. Axiom Studio was formed as an intensely creative environment meant to foster the best in digital design in all media and for both national and international clients. The studio's clients include businesses in the financial services, professional services, and information technology markets that seek high-quality design and creativity spanning a range of platforms.

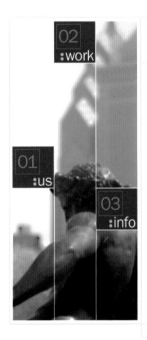

Axiom Studio delivers **compelling design** to define and enhance our clients' brands through the use of **superior design**, in-depth research and advanced technologies. We offer a complete suite of services to build and support your **communications** strategy across all media including: **print, web, kiosk, dvd** and **wireless.**

1.800.54.AXIOM :: eBranding for the eConomy™

above. The designers stuck to a single typeface throughout the design process, using different face weights to provide emphasis when desired. This approach unifies the elements on the page.

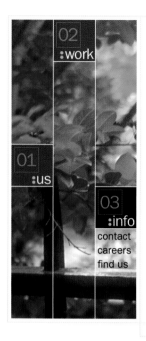

Located in Philadelphia, Pa., Axiom Studio serves clients on a **national** and **international** basis. Our **clients include** businesses in the financial services, professional services, and information technology markets that seek **high quality design** and creativity that will span a range of platforms.

Axiom Studio Incorporated
441 North 5th Street Philadelphia, PA 19123
T: 215.509.7686 F: 215.509.7688 info@axiomstudio.com

1.800.54.AXIOM :: eBranding for the eConomy™

above. The navigation animates on a vertical axis, in contrast to the horizontal layout of the site. This approach allows visual variety without the introduction of outside elements.

Redesigning Online Identity

Redesigning corporate or studio sites presents a different set of challenges than does designing and building a site from scratch. A certain level of knowledge is available, acquired from not only the production of the prior site but also from the daily maintenance of the content of the site inevitably wrought upon the developers. This exercise in rediscovery is refreshing. McDonald experienced it firsthand when he undertook the redesign of Axiom's own site—a project unlike his usual work. Describing its defining attributes, McDonald says, "First, this was our own story, so we knew the information thoroughly, though that doesn't necessarily make it easy to tell a good story. Second, this

project represented a refinement of our existing site, so we had done a lot of work the first time around and gained some insight into what we wanted to say and what worked.

"At the same time, because it was our own site, we had to balance our work effort with the realities of business. After all, we are still a relatively small company (midsize in our industry) and couldn't afford to dedicate a team to developing the project full time. Customer work took priority. Because this was both an upgrade and an internal project, we didn't go through our formal development process. However, we did follow the key elements to ensure we had a high-quality product," McDonald adds.

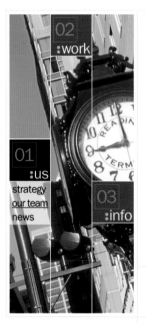

our team:

Michael McDonald :: VP - Chief Creative Officer

Education: BFA Graphic Design, Tyler School of Art
Inspiration(s): My Father, Family, SwissDesign, U2, Picasso, Frank Loyd Wright, Enigma, Ogilvy, Moby, The Film π , CoolHomePages.com
Passions: Family, Faith, Design, Typography, Color, Urban Living, Truth, Justice, Organization

01**management**02creative03**client services**

1.800.54.AXIOM :: eBranding for the eConomy™

above. The designers chose to employ groups of three, including the navigation, subnavigation, and tertiary navigation. This consistency adds to the visually symbiotic relationship the design elements share.

Thoughtful Concept Design Is as Important as Information Architecture

The adage "everything has a purpose" has no truer meaning than to good Web developers. Understanding that the design process is an additive and a subtractive process can make for a compelling online experience. The team at Axiom took this thought to heart, scrutinizing every aspect of the site redesign, taking into account as much interactivity information as they could gather throughout the process. "During the process we looked at literally hundreds of Web sites," recalls McDonald, "along with TV images, fashion magazines, and books to develop an overall context for our design. We had been researching Web sites from around the world and in every industry for some time and have observed and recognized many fads and trends. We wanted to enhance our online brand and give it longevity while helping it stand out from other Web sites, particularly our competition in the design industry.

"Realizing that we needed a simpler approach, we scrapped our initial design. We started with our logo, whose three colors are orange, silver, and black. We decided to use the concept of three as the basis of our design and as a way to reinforce our brand. Odd-numbered groups are good to work with because they make it easier to create asymmetry and imply an organic nature. Finally, we concluded that we could tell our whole story through this mechanism and that the user experience would be enhanced through the simplified access.

"I tried to envision how different people would respond to the site, from a twelve year-old to a senior executive. We used large type to enhance legibility but worked to keep it from appearing clunky. We went back to the basics on type and layout and were pleased to be able to limit ourselves to a single face."

Navigation as the Primary Design Element

The site's navigation is its primary visual element. Using their concept of three, the designers developed a navigational system that not only provided the necessary guidance through the site but also featured stunning photography in an otherwise flat-colored design layout. The photography constructs itself when the user clicks on one of the three primary navigational points. This area of the site is easily the most intriguing visual element, as the team at Axiom believes it should be. "Navigation is the core element in any user interface, whether in a Web site, palm, cell phone, kiosk, DVD, or any other interactive device," says McDonald. "At Axiom Studio, we have developed a variety of navigation techniques. First, the Web site standard, primary, secondary, and tertiary navigation, large graphical text that describes main areas of interest—for example, Home, About Us, Products. We also employ experimental navigation that requires the end user to interact and to explore the interface with imagery, numeric systems, or iconography."

process:

Axiom Studio has developed a formal **project management process** to ensure our **clients' success**. Through the rigorous employment of our comprehensive 5-phase process **our experienced team** will work with you as an **intuitive creative partner** ensuring that you receive the highest quality work **on time** and **on budget**.

User Instructions: Learn more about Axiom Studio's Five Stage Process by dragging your mouse and moving it to various phases of the timeline below.

1.800.54.AXIOM :: eBranding for the eConomy™

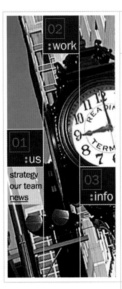

news:

10.12.01 **Axiom Studio Gains Recognition for Innovative Design** :: Axiom Studio selected as a finalist at the Int'l FlashForward 2001 Conference and Film Festival to be held in Amsterdam.

08.15.01 **Axiom Studio Unveils New Site** :: The Philadelphia-based digital design firm, today unveiled its new Web site.

04.20.01 **Back to Back Philly Gold Awards** :: Axiom Studio,Inc. has gone two-for-two at the ADV Philly Golds awards.

03.21.01 **CEO Discusses the Future of eCommerce** :: Donald Fisher, CEO of Axiom Studio, Inc., presented his views on the next generation of e-commerce web sites.

1.800.54.AXIOM :: eBranding for the eConomy™ sound track ☐ ☐ ☐ on | off

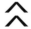

top. The subnavigation drops down beneath the primary navigation boxes. This visual continuity echoes the straightforward design of the site.

bottom. The designers chose to create news item headlines and links to PDF documents that open in a new window rather than creating page after page of news item headlines and their copy. This not only creates a cleaner interface by eliminating mass amounts of text from the screen, it also allows interested readers the ability to easily print press release material.

left. The simple animations of the portfolio navigation bring subtle interactivity to an otherwise static viewing experience.

solution: Axiom Studio re designed and expanded the user interface drawing on its successful experience with other kiosk projects. Using Macromedia FLASH and Generator we created a flexible solution that provides a foundation for future expansion and is easily refreshed.

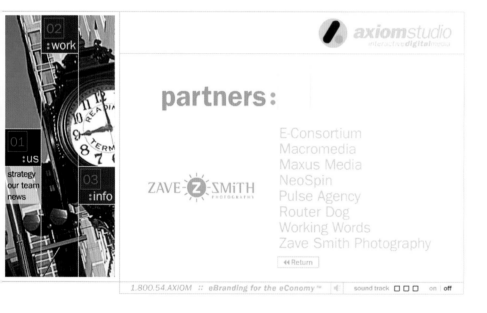

The Result

above. Instead of showing a page full of colorful partner logos cluttering the screen, the designers chose an elegant fading transition of the logos. This kept the page clean and gave visual importance to the logos as they appeared.

The result is a perfect example of design theory in action. The team at Axiom used every tool they had to create an environment that met their goals and stayed on course, according to their own design standards and research. "A solid background color, strong typography, simple usage of imagery, and good use of negative space all help convey minimalism," says McDonald. "Axiom Studio's Web site specifically conveys a clean, honest character because it is built on a traditional grid system. This grid system allowed us to focus on our approach. When you build an online brand, it is important to remember that to tell an effective story about your company, brand, product, or service, you must be clear, direct, and focused in your approach."

"The content is clear and is communicated directly to users without the addition of unwanted noise."

Design as a Subtractive Process

redpathphoto.com

The Redpath Photography site is a stunningly simple presentation of the photographer's work. No element on any page lacks a function. There is only design in its purest form—the simple communication of ideas. By eliminating unneeded visual clutter, the designer truly isolates the message to be communicated: Redpath Photography.

Stephen Bennett chose to design in the interactive world for the depth of landscape it provides. The ability to create and foster communication through design has fueled his appetite to explore the world around him and the many relationships life offers. Bennett and his partner, Shelley Rostern, founded Practicing Farm, a Vancouver-based design studio, in 1999.

Redpath Photography is the studio of Anthony Redpath, who translates his experiences and observations directly into his photography. The resulting images convey pertinent concepts through strikingly expressive compositions.

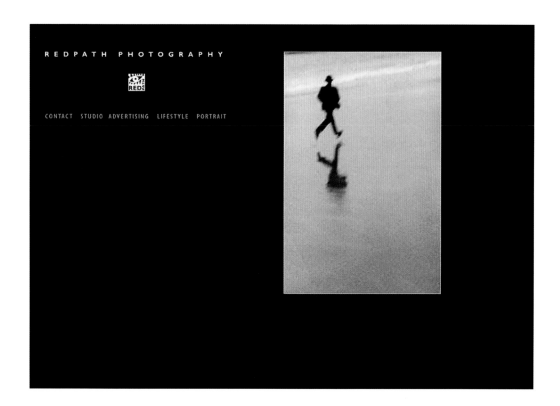

above. It doesn't get much simpler.
Navigation is on the left, content is
on the right, and there is nothing
else to distract the user.

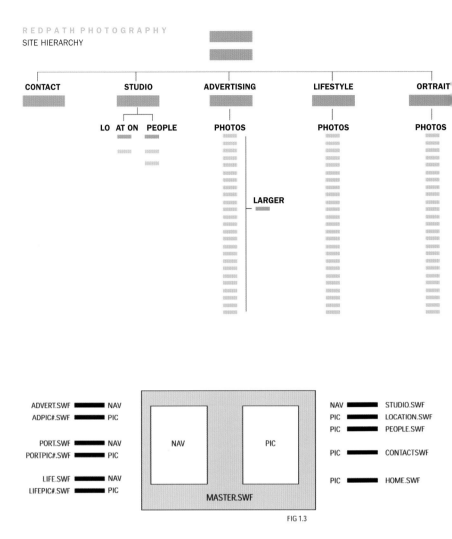

CONTACT STUDIO ADVERTISING LIFESTYLE ORTRAIT

LO AT ON PEOPLE PHOTOS PHOTOS PHOTOS

LARGER

Less Is More

The Redpath Photography Web site is the visual representation of the phrase Less Is More. Built on a foundation of simplicity and function, the site provides exactly the amount of information the user wants—nothing more. Its design follows the stringent artistic philosophy of its designer, Bennett. "I think there is a strong trend toward visual minimal design—it is merely the next step in the Web evolution," says Bennett. "Generally, I feel this is happening because the Web is much smarter than it has ever been. Developers understand site requirements and are able to define what the site needs to do; clients are better informed about the Web and are willing to invest more in the user experience; and users are much more willing to become active participants."

"Minimal design has become so strong because the Web needs clarity. When I think of minimal design on the Web, it's not just about the minimal use of layouts; it's also about the organization of content. Users need to find information quickly, and sometimes the fastest way to any location is a straight line. Forget about the overuse of heavy graphics and animation—define what the site is about and present it in a clear, concise manner."

ADVERT.SWF — NAV
ADPIC#.SWF — PIC

PORT.SWF — NAV
PORTPIC#.SWF — PIC

LIFE.SWF — NAV
LIFEPIC#.SWF — PIC

NAV PIC

MASTER.SWF

NAV — STUDIO.SWF
PIC — LOCATION.SWF
PIC — PEOPLE.SWF

PIC — CONTACTSWF

PIC — HOME.SWF

FIG 1.3

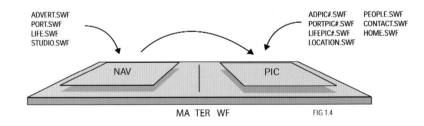

ADVERT.SWF
PORT.SWF
LIFE.SWF
STUDIO.SWF

ADPIC#.SWF PEOPLE.SWF
PORTPIC#.SWF CONTACT.SWF
LIFEPIC#.SWF HOME.SWF
LOCATION.SWF

NAV PIC

MA TER WF FIG 1.4

top. A basic site architecture map need not include every bit of information a site will display. Sometimes the simplest of documentation is better for keeping everyone on track.

bottom. This site structure map allows both the client and the designer to understand where elements are to be placed and what they will be called.

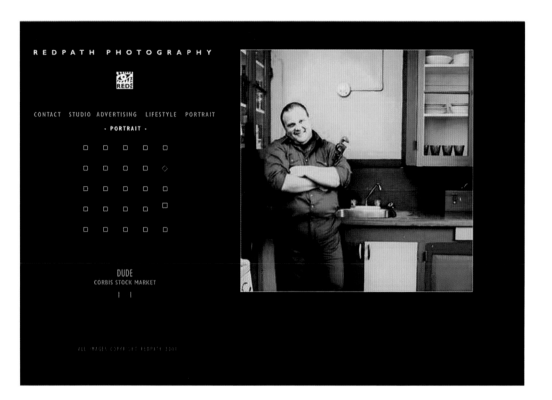

Design Should Not Compete for the User's Attention

The purpose of most photographers' Web sites is simple—show the body of work. This can be accomplished a number of ways. Bennett's choice was to create an environment that would showcase the work cleanly without competing with it. "For me, design needs to support the content," says Bennett. "If at any point the design takes away from the content or is more powerful than the content, then the design is not working. Users should be able to get what the site is about immediately, and when they leave, they should understand what the site was trying to say or do. If what they remember is that the intro screen or the roll-overs were out of this world, then the design needs to be addressed accordingly."

Documenting the Process to Be Followed

The desire to begin site design by designing interfaces is a common temptation. Organization and understanding the objectives of the project should be the first tasks addressed. Bennett believes that consistent documentation throughout the process comprises the best hope for a successful design. "Before I start any creative concepts," says Bennett, "I first attempt to capture what exactly the site will need to do. This process involves a series of documents I use to conduct a needs analysis, establish the goals of the site, and identify key requirements to fulfilling the project. Documentation is a somewhat tedious, unfulfilling phase, but it helps me gather everything I need before the build."

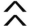

above. The loading animation, located under the title of the image displayed, is consistent with the elegant design of the site.

Navigation in Its Purest Form

The navigation of any site is crucial to the delivery of content. The navigational scheme at the Redpath Photography site is extremely simple and easy to use. "I believe that navigation should be smart, but not smarter than the user," Bennett says. "With Redpath, I chose to use a mix of alphanumeric and icon navigation. The alphanumeric approach is straightforward; it gives users an exact feel for what is available. The icons [squares] were used to allow users to explore and reveal content as they choose. The success of the navigation on redpathphoto.com is due to its ease of use. It doesn't require effort from users; it simply connects them to the content. The minimal layout enhances the navigation. Users are not challenged but benefited."

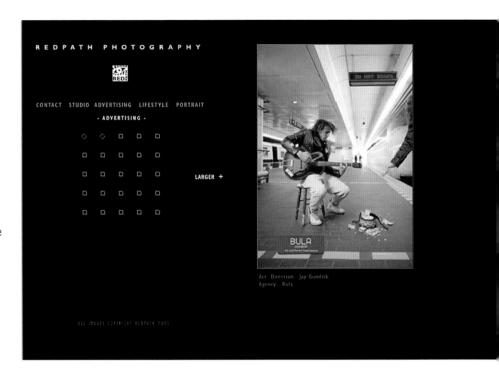

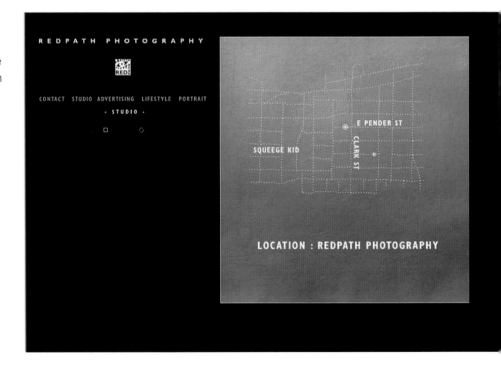

top. The designer chose to use extremely small, square icons to represent the available content. To quietly and cleanly show what content has already been displayed, the designer rotated the squares to form diamonds and grayed them out, keeping the page light and open.

bottom. The map area of the site, while cleverly produced, still projects a minimalist feel.

Stepping Outside the Designer Role for Vision

Bennett had to display Redpath's photographs properly. Executing this task poorly would undermine the rest of the work. "It is fairly easy to make things look cool," says Bennett, "but to design an experience that pushes content and provides users with knowledge is a different matter. It is good practice to step outside of the design role and place yourself in the client's shoes. Ask yourself what you want users to get from this site and what benefits you want to give them. Once you have answered these questions, you can fill in the blanks in the design."

"After some rough drafts of the page layouts, I looked at the page types, and if any element did not add direct value to the content at hand, I deleted it from the page. Slowly I came up with an elegant look that had a purpose behind it. The minimalist approach was there from the beginning, but by testing each element on the page for its direct value to the experience and content, I was able to refine the look."

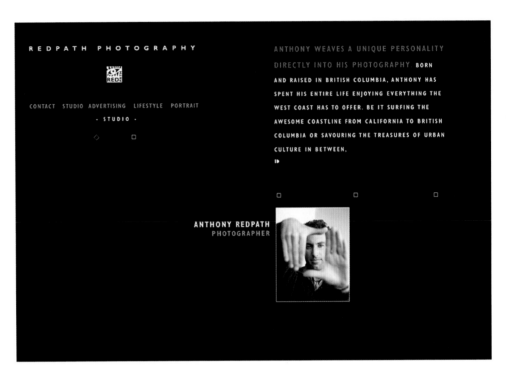

above. The dedication to presenting no more content than is absolutely necessary carries through to the biography page as well. Using typographically extended phrases opens the words up, allowing more space between letters and reinforcing the overall simple interface.

The Result

"Visual minimalism is not necessarily about the use of white space," says Bennett. "For me, it is about clarity. Connecting using the least amount of effort is true minimalism. It is like the saying 'He who speaks does not know.' I feel this applies to the Web as well. I see sites that slam me with information from every direction. I get overloaded with information as they try to grab my interest on twenty topics at once. These sites express a philosophy of More Is More. Every inch of real estate is used as they try to push their content. To me, these sites lack confidence. They are unwilling to let users explore and experience."

Clean, Eye-Catching Site Design Draws in Users

golfinfo.at

The Golf in Austria Web site uses beautiful, almost surreal, photography; clean, straight-lined layout patterns; and classic typography to provide information easily and quickly to the user. By using a neutral color palette and clean layout, the designers have created an environment that allows the user to focus on the content.

World-direct.com provides strategic, creative, and technological solutions to digital businesses all around the world. Markus Hübner, chief creative officer for World-direct.com, started in the industry by founding SecuNova, a communication design firm, in 1997. Two years later he founded World-direct.com Inc.

Golf in Austria is an association of specialists on golfing vacations in Austria. Eighty-four golf hotels and forty-seven golf clubs are at work to guarantee the ideal golfing dream vacation for golf enthusiasts.

GOLF **IN AUSTRIA**

MYGOLF HOTELS CLUBS PACKAGES SERVICE SHOP KONTAKT

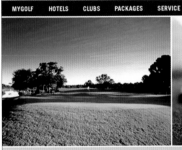

Relaunch | the story

Ihr Golfspezialist in Österreich mit neuem Internet Auftritt.

Willkommen bei Golf in Austria.
Sie können sich hier anmelden.

Seit Bestehen der golfinfo.at sammeln wir Ihre Wünsche und
Anregungen, wie wir Ihre Informationsplattform für Golfurlaub
in Österreich noch besser gestalten können. - Voilà, hier ist
das Ergebnis. Die altbewährten Informationen über Golf in
Austria-Hotels haben wir ein bißchen ausgebaut, damit Sie sich
einfacher über Ihren Traumurlaub informieren können. Ganz
neu sind dagegen die Informationen über unsere 40 Golf in
Austria-Golfclubs und die 7 Übungsanlagen. Schauen Sie sich
um und wenn Sie wollen, senden Sie uns Ihre Kommentare.
Wir freuen uns über Lob genauso wie über Kritik, schreiben Sie
uns, wie wir Ihre golfinfo.at optimal für Ihre Bedürfnisse
gestalten sollen.

01 GIA WEBSITE
 AWARDED
 Unsere Website
 wurde mit
 internationalen
 Anwards
 ausgezeichnet.

02 TOP GOLFINFOS
 PER E-MAIL
 Lassen Sie sich
 Ihre persönlichen
 Golfinfos per E-mail
 nach Hause oder
 ins Büro liefern.

03 NEWS VOM
 PROFISPORT
 Alles über Golf in
 Österreich,
 Turniertermine,
 Ergebnisse und
 Neuigkeiten.

ENGLISH VERSION | HOME | SUCHEN | MAIL

above. The site's underlying layout grid
is introduced here. The imagery is both
appropriate and needed to contrast the
neutral color scheme.

Designing to Stand the Test of Time

The neutral color scheme of the site leads the eye to the content by framing the vibrant color of the photography and the starkness of the text's background. The gridlike layout, with its open, rectangular content area, allows the images and text to be presented with similar focus by encasing the content with color. The layout also enables the client to add content to the site as needed—keeping the site relevant as time passes.

The site's glaring simplicity was no accident. The designers on the site wanted to strip away anything that didn't help the communication of the content. Eliminating distracting elements allowed the designers the room to present content as effectively as possible. "To me, the adage 'less is more' means the absence of unnecessary complexity," philosophizes Hübner, "while retaining design elements that further effective communication. Reduction is a tough challenge and needs experience to reach a successful result."

"Young designers are more apt to play around with filters and explore the envelope of their graphic tools. This often leads to design that has to do with the abilities of the image editing application than with design as a communication tool. The design style should depend on your target audience and which approach is the most appropriate to that audience."

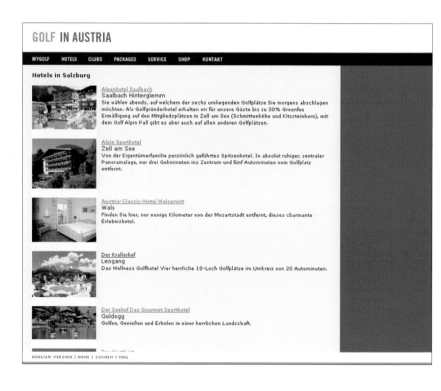

top. Not every image within the site is golf related. The designers occasionally chose imagery that was appropriate to the concept of the section it appears in without detracting from the overall style of the site's photography.

bottom. The designer chose small images and brief descriptions of the resorts to allow the user to quickly scan for interesting destinations. This method also allows the designer to reinforce the visually simple approach of the site.

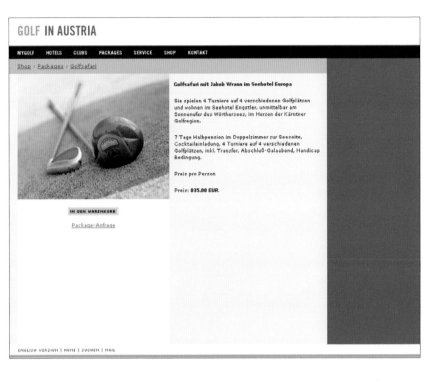

left. By introducing another neutral color into the design, the designer can both visually separate navigational areas as well as provide visual interest to the page.

Determining the Project's Goals Ensures Consistent Results

Many designers begin designing a site without paying proper attention to the site's audience and to how the site should fit into other marketing models the client may have employed, such as product or service brochures or catalogs. Designers often focus on the properties the design is to display and the emotion the site is to invoke without understanding the end user or the purpose of the site.

The designers for the Golf in Austria site paid close attention to the end user and the site's objectives before starting the design process. This ensured that they understood the site's goals and that any elements not achieving these goals would be eliminated. "At the very beginning," remembers Hübner, "we met with the client to discuss the underlying communication needs of the site—what the project goals were, what the desired effect of the Web site was, analyzing the target audience, new media brand management (transferring brand values to the Net and applying Internet-specific rules to an already existing communication strategy), what made the site unique, and why customers should return."

"Based on the results of this meeting, we tried to get a true understanding of the target audience and the intentions of the client. The challenge with this project was in creating a unique and enjoyable online experience to a target audience that is somewhat differentiated (everyone who is interested in golf)," added Hübner.

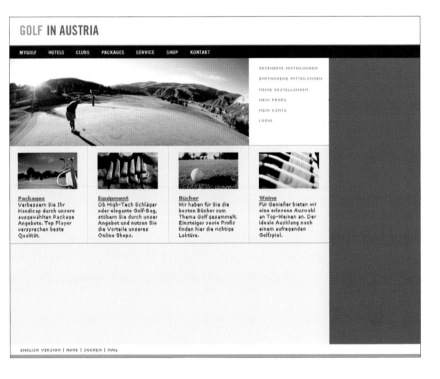

above. The panoramic photography provides reinforcing visual room to the page. By complementing the main image with smaller images, the designer creates a look that is clean and precise.

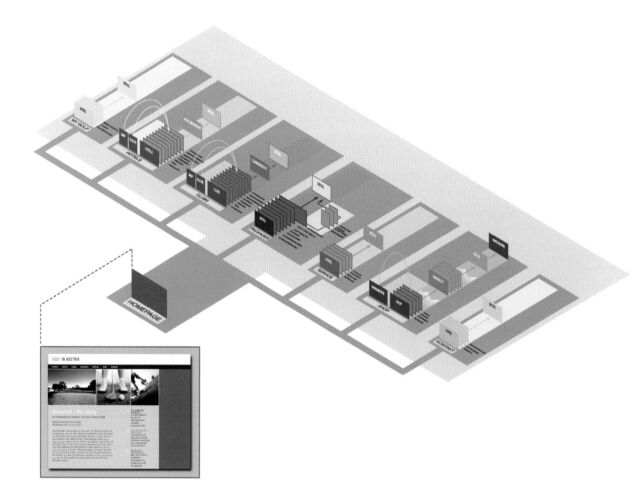

The Site Map as the Guide to Design

Before the design process began, the designers created a site map to help them collect and understand not only the content but the presentation of the content and how the content pages related to one another. "Interface design on the Net is all about providing the right amount of information in a fast and easily accessible way," states Hübner. "When beginning interface design, content provides the guidelines of what design freedoms or limitations the designers will face but does by no means restrict design. To ensure this goal (understanding the freedoms and limitations of the design) is met, we built a developmental site map. The site map is a powerful tool when designing individual pages or templates, as you can easily see the connection of each page to the whole structure of the site."

"We wouldn't want to begin the visual approach to the site without some sort of idea about the site's impending structure. The visual approach is closely knit to the site structure and content. The color scheme, the typography, and the imagery are all designed at once, so we want to make sure each reinforces the objectives of the site," added Hübner. The site structure speaks as much towards the idea of visual simplicity as the graphic design does. Without a clear idea of how each of the elements work together, it is difficult to understand which elements are needed and which are not.

above. The site map is extremely comprehensive, including how navigation will link to other documents within the site. The designers also included the design of the page to allow for a clear understanding of how content will look once presented.

Focusing on Distinct Design Goals

The actual design of the site revolved around three distinct design principles —the layout grid, the typography, and the color scheme. Each works harmoniously with one another to effectively communicate to the end user. "The layout grid has a major impact on the feeling around the Web site," noted Hübner. "It's vital to hold together related elements, such as content and imagery, and leave enough white space between other areas of the page to create a visually simple experience where content is easy to find and the imaging is both appropriate and minimal. A great deal of time was spent on typography as well. When the type fits perfectly, it contributes so much to the harmony of the Web site by visually connecting the emotion of the imagery with the information."

With such an emphasis on the simplicity of form and the importance of the content, the designers chose to create a visually simple navigation bar along the top. By choosing to pop up the subnavigation, the designers could clear visual space for other elements on the page. This deliberate approach adds to the already simple site structure. "The navigation should fulfill the purpose of browsing through the Web site yet remain in the background so that users can concentrate on the content," mentions Hübner. "Sometimes, navigation is so obtrusive that it's quite impossible to focus on content."

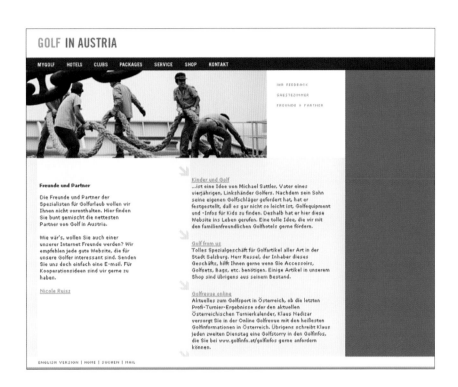

above. There are subtle tone changes in the content area that serve to separate content subjects. In this way, the designer can continue the overall feel of the site without distracting the user's attention from the content.

The Result

The result is a stunningly beautiful and useful site, with just enough imagery to convey the mood and emotion of the subject matter without hitting the end user over the head with the subject. "The individual character of the Golf in Austria Web site," concludes Hübner, "is conveyed via a restrained color scheme, clean typography, enough white space to lead viewers to the content, and an accessible layout grid, but most important of all, these elements interact in a balanced environment."

"The simplified approach was the best solution for the site requirements, which were to convey elegance and the appropriate atmosphere. This simplified approach enables users to perceive the spirit behind the site."

"Each element on the page should have purpose.
If it has no purpose, it should be eliminated."

Using Color to Aid Visual Simplicity

venusdesign.de

The VenusDesign site uses a large background image and small, constrained content areas to communicate both the overall mood—mysterious yet inviting—as well as the informational content. The consistent use of red in the site's background, although bright and bold, simplifies the overall design by focusing the user's attention on one singular area of contrast. Soft, dreamlike photography incorporated into the background image provides a human element to the text information and allows the user to feel more comfortable with the interface—as if there is someone guiding the user.

Pixelizer is the personal freelance name for Pierre Brost, a Web designer living in Germany. Brost started working on the Web in 1997 and has created online communication pieces for dozens of clients worldwide.

VenusDesign is both a personal expression project for Brost as well as a profile and digital playground for an acquaintance. The site is a means for Brost to experiment with different interface ideas and applications, giving him an outlet to try new things and judge their effectiveness.

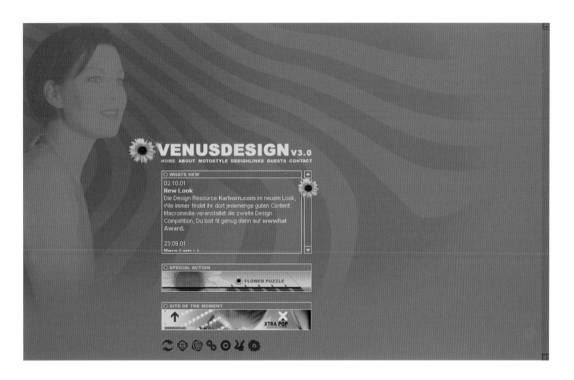

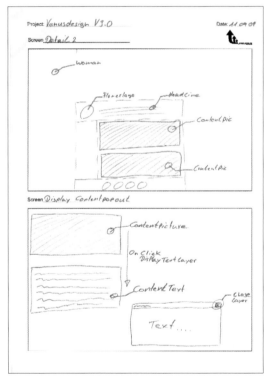

above. The large background image brings focus to the content area without cluttering the page with unnecessary images and full-color graphics.

above. In the developmental stages of the site, the designer describes how the site will both look and function, noting the progression of content presentation on user click-through. By considering the functionality of the site, the designer can begin to map out how content will be pared down and presented.

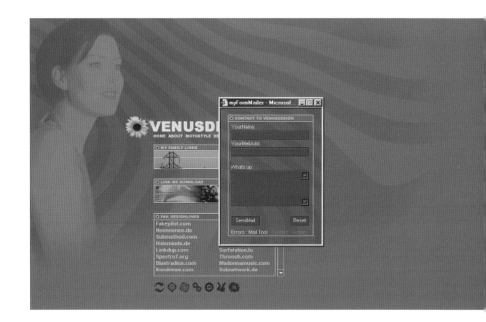

Using Background to Set the Overall Tone

Because the content is presented in small, rectangular boxes, rather than filling the screen, the designer is able to control and simplify the design environment. Introducing the content a few inches from the top of the screen also simplifies the site by creating a space void of content, thus keeping the site from appearing cluttered and overwhelming.

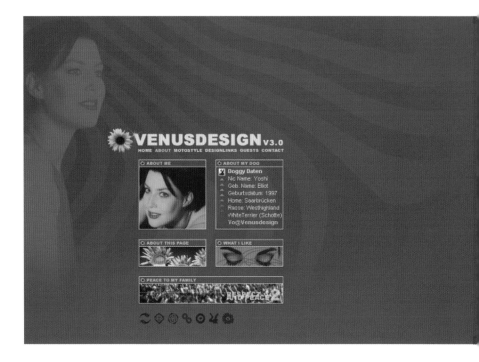

top. Part of what makes the site seem visually minimal is the consistent use of red throughout all of the imagery on the site, as well as the color's inclusion in the functionality of the site, as in the form fields and scroll bars.

bottom. By restricting the content to defined rectangular areas, the designer prevents the content from expanding and creating visual clutter.

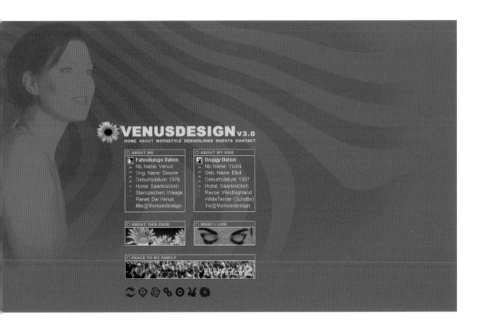

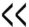

left. By using content-presentation images, the designer creates a simpler page by reducing the amount of text. The text appears only when the user activates it by clicking on an image.

above. Being both the designer and the programmer often allows for the developmental sketches to contain both graphic and functional notes about how the content will be presented and where it will come from. This gives the designer the luxury of knowing the size of the content, therefore creating a more harmonious environment.

When the Designer Becomes the Programmer

Designers represent only one step of the production process; producers, writers, and programmers are also involved with the site during its production. As a designer, it is often difficult to hand off the design of the site to other production staff members for fear that the designer's vision will somehow get lost in the transition. This fear is the primary reason designers create detailed site maps to follow—so that every member of the team is on the same page.

Another way to keep the core message of the site intact is to avoid handing off the site to someone else. This can only happen if the designer has the ability and the responsibility to perform the other tasks needed to build the site. With the VenusDesign site, Brost acts as

the designer as well as the programmer, which helps to ensure that his vision stays intact. This combination of responsibilities helps simplify the production process by reducing the prospect of changes or alterations to the original concept.

Brost considers this combination of talents to be a new direction in Web design. "I think this is a new type of art form," states Brost, "the ability to design the content interface as well as produce its delivery methods. New programming technologies, such as DHTML and database connectivity, have opened new avenues for the interaction between content and design, and I think if the same people can act as both designer and programmer, the site can be better planned and produced."

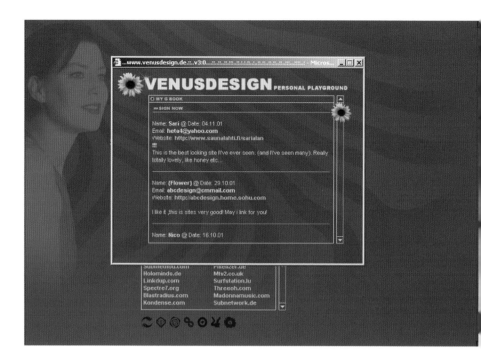

Image-Based Content Presentation

The design detail in the VenusDesign site is not derived from finely tuned graphics or eye-catching animation but rather from the attention paid to content presentation. The manner in which the content is presented is the visual focus of the site. Content is first presented visually within the boxes, with introductory information seen at first glance—a click on the content boxes displays detailed information about the subject. This style opens up space, providing a simple, clean interface—free of clutter and unnecessary visual elements. "The content was reduced to what was essential to communicate," notes Brost. "There are two kinds of content being presented in the site, images first, then text when the user clicks through on the image. I think people are naturally drawn to imagery first, visually, then to text-based information. I wanted people to be able to know what section they were entering, but leave the core of the text-based information to a user action."

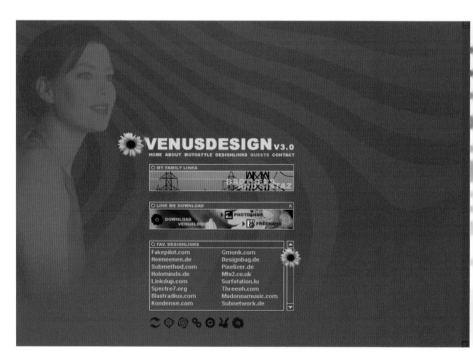

top. The flower is one of the recognizable icons in the site and appears in the header areas of the sections. The designer carried through this icon into what would normally be browser-defined functionality, such as the scroll bar on the guest sign-in page. This consistency lends itself to the overall simplicity and character of the site by carrying through elements to make the user feel more comfortable within the site without using the exact same layout.

bottom. The unusual stripes in the background are used to keep the design visually contained. Without them, the content and the image of the girl would feel misplaced and floating without a grounding element to connect the two.

**Defining the Balance of
Content and Design**

One of the advantages
to being both the
designer and the pro-
grammer is the ability
to integrate content and
design in a more fluid
manner. Content can be hard-
coded, meaning it is always the
same and part of the page, or it can
be dynamic, meaning it is stored in
a database and will be introduced
into the page when the user asks
for it. When the designer knows
exactly how content will be intro-
duced and how it will be presented,
the designer can better integrate
the content into the design.

This integration leads to a
better understanding of the purpose
of the site and, in this case, has led
to a simpler overall design. "I feel,
in general, Web design's purpose is
to create a way for the user to be
able to get the information they are
looking for as quickly as possible,"
states Brost. "Finding the correct
balance of content and design is
always the main challenge, and
acting as both the designer and the
programmer helps to define that
balance. I wanted the content in
the VenusDesign site to become one
with the design, not be separate or
apart from the design. Presenting
the content was the design."

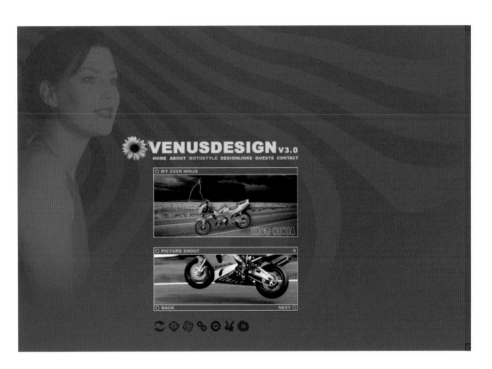

above. Contrast and color are two very
powerful tools designers can use to
draw interest and attention to certain
areas of the page. In the Motostyle
page, the designer uses both duotone
and full-color graphics on the page to
lead the viewer's attention and focus
to the areas of the page.

The Result

The result is a site that is clean, simple, and direct. The color scheme does not distract the
user from the content; instead, the color complements the content and creates a contrast that
allows the user to focus attention on the content area. The duotone treatment of the imagery
and the centered placement of the text-based content also help to communicate this focus.
"Paring content down to only what is needed, then presenting that content as effectively as
possible, will help to reduce visual clutter and create a more focused project," Brost states.

simplifying the user experience

User experience is all about removing obstacles from the user's path to the information. Whether designing a site for themselves or telling a story through design, it is the designer's responsibility to present the necessary information in the order it is meant to be received. That is the essence of effective user experience.

The features in this chapter present a variety of challenges the designers were faced with and illustrate how the designers overcame them in a simple and structured way. Most of the designers used basic organization and common sense to direct their presentation of content.

Not enough emphasis is placed on the thoughtful organization of content prior to design. It was once said that a problem well-defined is half solved. That means if designers know what is to be communicated and in what order before they begin the design process, they will find the results easier to obtain. Simplicity isn't always the result of visual minimalism—it can often come from proper attention to organizational duties before production begins.

Designing for the Design Firm

300feetout.com

The 300 Feet Out Web site is a clean, straightforward example of design exploration bettering the user experience. Content is presented and focused through the exquisite use of color and negative space.

A leading visual communications firm, 300 Feet Out focuses on translating business concepts into corporate identity systems and Web design. The company's philosophy is *Work. Live. Play.* Because inspiration comes at unexpected moments, the company pushes the verb *do.* Its designers bring to their work inspiration from life around them. They observe. They listen. Their main objective is to ensure that their clients stand out, that each client's message is memorable. They want their clients to succeed 300 feet out beyond their expectations.

How can we stand out from a crowd of seasoned design firms? This is the question that every design firm must answer when developing its own Web presence. It's the question Nina Dietzel, cofounder of 300 Feet Out, had to answer as she began to develop a corporate identity online. What design direction would demonstrate both the design philosophy of the studio and the capabilities of the designers? "Our design approach is intuitive," says Dietzel. "We weren't concerned with classifying our style or approach to the problem. We simply sat down and put all our cards on the table and reviewed the full deck. Our main objective was to simplify our process for those outside our company. Insider information is always more complicated and stacked with details. We had to drill down to the essential takeaway."

300FeetOut::Information Architecture

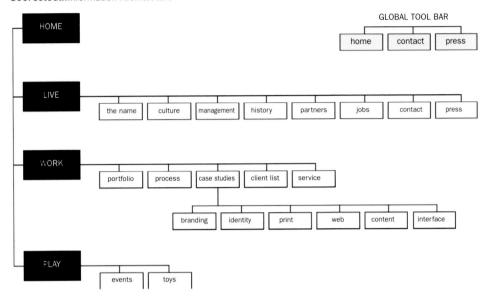

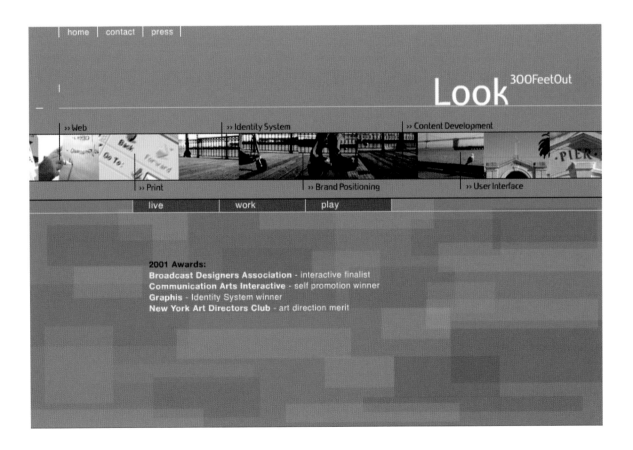

top. After finalizing the sketchbook wireframe ideas, the designers created a formal navigational tree structure to follow through the design process.

bottom. The band of images moving slowly across the screen allows the designer to introduce brand-reinforcing images in a clean and simple way.

The Overall Picture

The team at 300 Feet Out understands that designing for the Web is an additive and a subtractive process, a process that adds imagery for context and, at the same time, pares information to the most essential. Dietzel says, "Web design seems to be tethering between atmosphere and reduction. *Atmosphere* alludes to the way we can understand more in pictures than we can in words. *Reduction* is a rational process of making information accessible and easier to understand. Shaving to the essential is, in part, minimalism. Visual minimalism, the reduction, however, is only part of the picture. To completely understand information, we rely on context too, which pictures often help provide."

"Web sites must interpret a great deal of information concisely. Unlike print media, Web sites must be rapidly comprehended by their audience," states Dietzel. Online visitors tend to spend less time in one area than print media, mostly due to choices—they are presented with more choices and considerably more interaction online. In print media, such as a magazine, the user has already made the conscious decision to look through the magazine, as the topic or article is interesting enough to do so. "They will take longer from page to page, take in more. Information online is not linear; it's like taking a picture where the atmosphere is as important as the foreground," Dietzel adds.

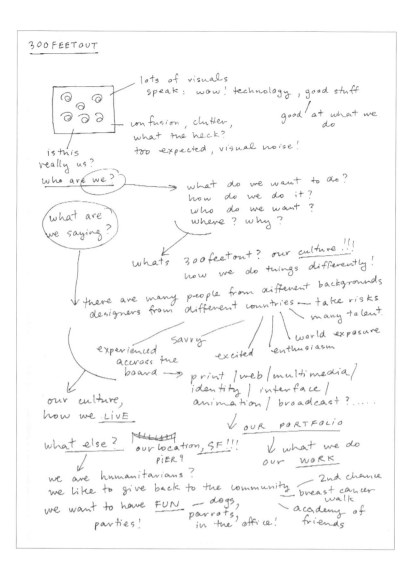

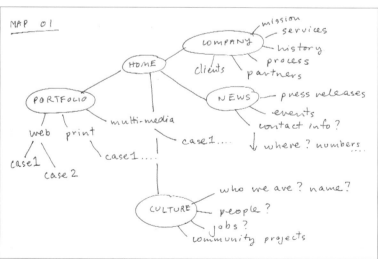

top. Ideas about navigation and layout were explored early on. The designers revisited them to decide if they were appropriate for the site.

bottom. This first pass at an organizational wireframe eventually evolved through further decisions but provided the basis for the final site architecture.

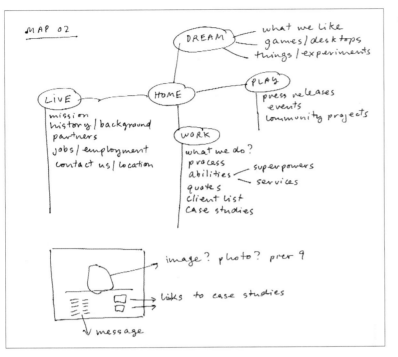

left. In this second generation of the wireframe, the basic navigational structure has changed and become more streamlined.

What Are You Trying to Say?

Designers developing their own sites must consider the effective balance of content presentation and design for design's sake. Many designers can't decide what to say and, more importantly, what not to say. They often bypass the collection of content and begin designing at once, figuring they know the content so well, they'll just fill it in afterwards. 300 Feet Out believes that content should be the starting point, not the last piece of the puzzle. "Design begins with content," says Dietzel. "When most people refer to design, they are thinking about pictures and imagery or layout. But, in fact, design must begin with the simple questions of what do you want to say and to whom do you wish to speak. Choosing words is as important as choosing colors. I think the visual and the verbal must balance each other continually in the design process."

"This was our own site, so we lived and breathed the content. I think our site is an example of why it is so important to be joined at the hip with clients. We need to build their trust. We must understand who they are and where they want to be. When we are familiar with our clients and their needs, we can build content into a seamless identity. When we build sites for outside clients, we try to get the content as early as possible. We're big believers in allowing time for understanding what the client is really trying to say. Content isn't a last-minute item. It's integral to the development of the project."

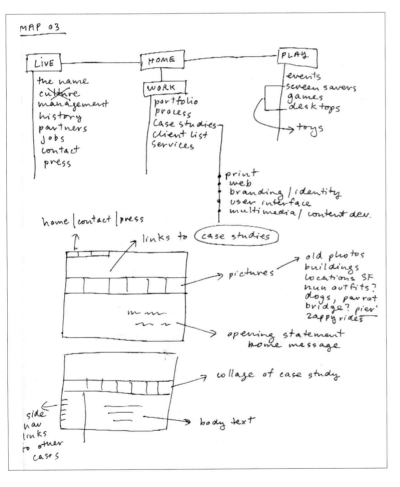

above. The basic site structure stood the test of time, but the subnavigation became more tightly organized, which makes the site easier to use.

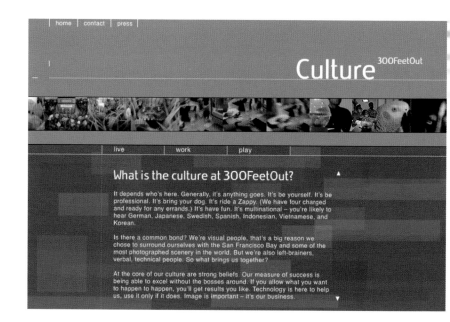

Building the Better Mousetrap

At 300 Feet Out, designers make a concerted effort to rethink and reevaluate what the world has come to know as standard. Creativity spurs invention. Everything is questioned. This pioneering spirit helps the designers invent better ways to explore and understand. The best example of this is their constant exploration of effective navigation. "Look at a well-designed building," says Dietzel. "A Neutra or a Meier, for example. Your experience as you walk through any part of the building has been predetermined. The architect has explored weather, lighting, temperature…changes that affect the way a resident will feel in the space."

"Equally, Web navigation must prethink all aspects of the experience. What information is essential? How will viewers absorb the material? Where will they most likely go? What options will they look for? How long will it take for them to gain what they want? What will be memorable with their experience?"

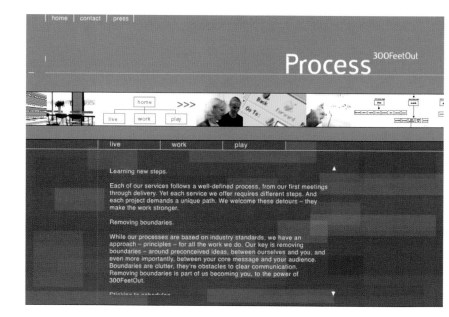

top. Instead of separating the site into corporate navigational sections, designers chose to go with a more conceptual approach—"Live. Work. Play." —to simplify the navigational approach.

bottom. The images in the band change to reflect the subject matter of each section, keeping the interface free of clutter.

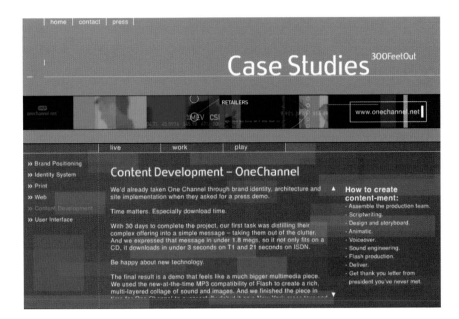

right. While the subject matter may be a bit dry, the simple treatment of the How to Create Content-ment section to the right adds a little humor and life to the message.

"There are always new ways of thinking about process. It's about breaking up tradition. Richard Saul Wurman observes that as you drive across America, the states are not alphabetical. Why must an atlas list all states alphabetically? Web navigation requires this type of rethinking," Dietzel concludes. This rethinking or reevaluating allows the designer to formulate new opinions of the importance of elements on the page and provide an opportunity to simplify the presentation and communicate more effectively.

above. The Play section was meant to be fun, so 300 Feet Out ditched the image band in lieu of a more colorful, kaleidoscopic presentation, while maintaining the overall simplistic approach.

The Result

To label the site as minimal in design doesn't fully categorize the style to the team at 300 Feet Out. "Minimalism is a difficult term to grasp," Dietzel says. "It's a bit like *the modern* in that minimalism is everywhere. It's more than simply clean of clutter. Simple is not necessarily minimal, yet it can be. To consciously pare down each part, to rethink importance and value takes great effort."

"Perhaps minimalism is a search for purity. Both color and form can be reduced to the essential, the pure necessity. Minimalism is a way to contextualize complexity. We must ask how can we make something easy to understand. When you see an image that works, it tends to stick in your mind immediately. We aim for simplicity and directness in design. We want design to not only translate to many audiences but also to tug at the strings of emotion. If [the message] is easy to remember, it usually works."

"There's a yearning within our audience for elegant, refined, and simple spaces—places that give them a chance to escape, breathe, and reflect."

Designing for a Documentary

becominghuman.org

The *Becoming Human* site is so large in depth of content, and the designers have done such an outstanding job at organizing that content, it takes time to recognize how deep the site really is. By using multiple entry navigation and pull-out points from the documentaries, the designers give users the option to move at their own pace. Using subnavigation and cinematic content presentation techniques, the designers created an environment that is surprisingly focused, taking into consideration the vast amount of content they needed to organize and present.

Terra Incognita is a studio that produces narrative-driven interactive documentaries and online exhibits—projects that tell compelling stories using the power of interactive media. The Terra Incognita team combines expertise in experience design, information architecture, interface design, and interaction design with content specialties in history, natural history, and cultural studies.

Becoming Human is an interactive documentary presented by the Institute of Human Origins and produced by Terra Incognita in association with new media firm NeonSky. The documentary explores the question of what makes us human. The visitor's experience is guided by paleontologist Dr. Donald Johanson. Guests can walk through a paleontological dig, meet leading scientists in the field, and trace the evolution of the human species over the last four million years. The site combines thirty minutes of linear documentary programming with fifty connected hands-on exhibits for deeper learning.

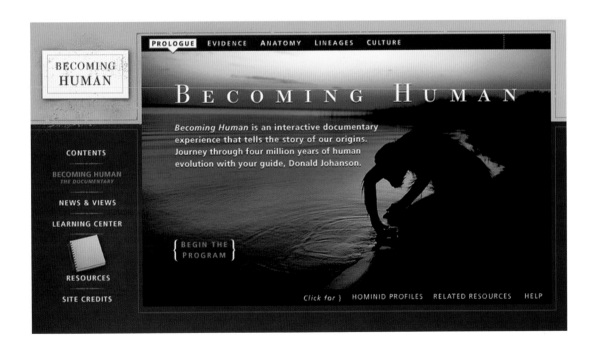

top. This unusual site map works from a visual standpoint to communicate to the client and other development teams what content exists within the primary sections.

bottom. The screen size is meant to be like a traditional movie or video format. Additional content is confined to a set area of the interface, which allows the designers to design within the rectangular movie area without disturbing the rest of the interface.

Storyboarding Site Content

It's a common question, one most Web developers are asked every day: "Can you take this six million years of content and create an entertaining and educational Web experience for us, please?" OK, maybe not every day, but the team at Terra Incognita was asked to do just that.

As if the documentation of evolutionary history weren't enough, Terra Incognita set an internal goal of presenting this information in a simple, elegant manner. "I think a lot of people are rediscovering the value of simplicity," says Bart Marable, creative director and principal of Terra Incognita. "The pressure on marketing departments to employ increasingly obnoxious approaches combined with the growing ease of crafting flashy animated presentations has unfortunately taken its toll on the quality of content on the Web."

"Albert Einstein said it best: 'Everything should be as simple as possible, but no simpler.' I think that with any interactive project, the visitor should be presented with only the choices that are absolutely crucial for an effective experience. Too many options, and the visitor is overwhelmed and confused. Too few, and he feels trapped and isolated."

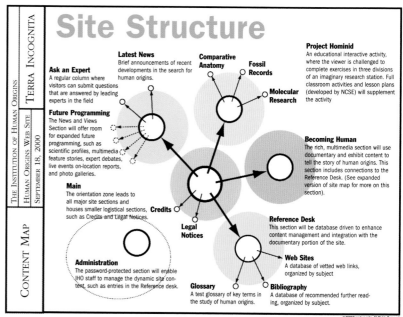

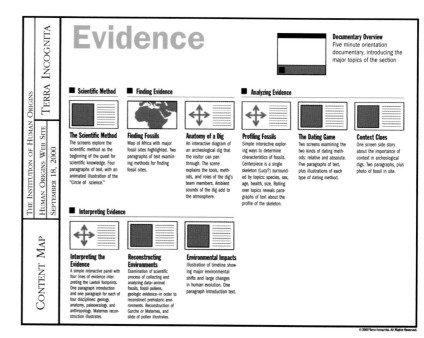

top. This visually focused information architecture wireframe includes content the client may want to add in the future.

bottom. In a project of this size, the client often needs to be walked through a preliminary content presentation to grasp the linear, frame-based animation structure.

Panel Exhibit (1)

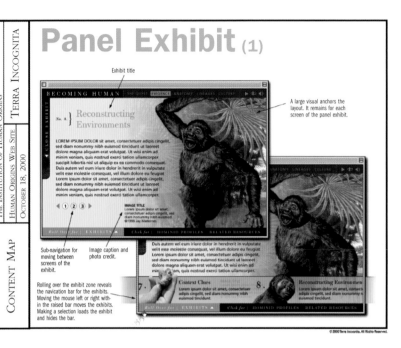

Exhibit title

A large visual anchors the layout. It remains for each screen of the panel exhibit.

Sub-navigation for moving between screens of the exhibit.

Image caption and photo credit.

Rolling over the exhibit zone reveals the navigation bar for the exhibits. Moving the mouse left or right within the raised bar moves the exhibits. Making a selection loads the exhibit and hides the bar.

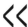

left. Keeping everyone on the team aware of subtle but useful details ensures accuracy and consistency across teams working on different pieces of the project.

Wireframing Can Evolve

So, how *do* you go about designing such a visually simple site with all of this content? Terra Incognita began by creating flexible, broad-scope site outlines, focusing them over time to accommodate content and content sections. "We approached the production of *Becoming Human* much like a film studio would produce a conventional documentary or a museum would produce an exhibit," says Marable. "Because the purpose of the project was to develop an original documentary production, the visual design and content development went hand in hand from the start."

"At first, our site maps were abstract—an exercise in finding the edges of our subject. We weren't as concerned with the final form of the site sections—for example, the number of screens—as we were with the stories that the sections needed to tell. But as the planning continued, our maps and planning documents became increasingly detailed. By the time we were finished, we had dozens of documents outlining an experience that comprises thirty minutes of television-style programming and nearly fifty interactive exhibits."

"Because of the scale of the project, we found it helpful to develop a pattern language for the various features in the site. For example, while each exhibit we produced had unique features and design, it also fit into one of several exhibit patterns. Some, like the panel pattern, were simply text and a photograph. Others, such as the map and gallery patterns, were more complex and interactive. Defining the scope of the patterns before we began developing content for specific exhibits gave both our team and the client an idea of the scope of each exhibit."

Breaking Down Navigation into Simpler Structures

Once a coherent site map (or, in this case, site maps) is created and the outline of the site is in place, the next daunting task is deciding how the end user will access the information. Terra Incognita decided to give the audience a choice of experiences. "Navigation is crucial to giving visitors what they are looking for," notes Marable, "whether it's a quick answer to a question or an immersive learning experience. In *Becoming Human,* we had to accommodate different learning methods through a variety of navigation options. We also had to design the site to appeal to multiple interest levels. While some visitors may have a good working knowledge of paleontology, we knew that others need a compelling introduction to the subject."

"Our solution was to develop three distinct but interconnected experience tiers. The top tier, which we called the Documentary level, was designed as a lean-back experience visitors can watch like a television program. The second tier, called the Exhibit level, is more interactive than the Documentary; it is richly designed with hands-on activities and strong visuals. Finally, the third tier—the Reference level—is a database-driven reference desk with a glossary, bibliography, and Web site directory."

Each level can be independently experienced. However, visitors can move easily between levels. For example, Documentary-level visitors can follow a teaser to a related exhibit. The Related Resources tab also brings up context-sensitive content based on current location. If a visitor to an exhibit about bipedalism selects the Related Resources bar at the bottom of the screen, it loads Web sites and other media related to bipedalism.

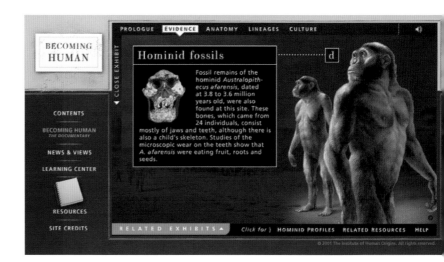

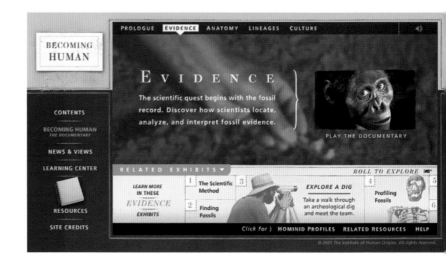

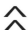

top. The main documentary is broken into smaller documentary subjects, which allows visitors to decide just how much information they want to see.

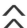

bottom. All of the documentary sections include a sliding Related Resources bar at the bottom. A wealth of additional information is thus available, but it does not intrude on the visitor's experience unless he asks for it.

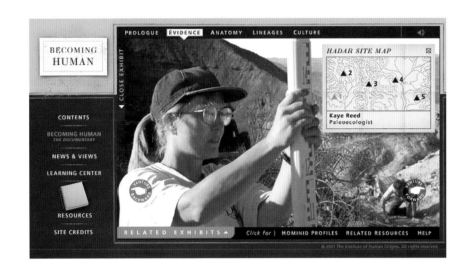

The Art of Subtraction

An overall positive user experience can often be attributed to understandable navigation and clear, simple design structures. The design of the site had to provide the appropriate combination of entertainment and information. "We decided to make the interface as simple as possible," says Marable. "In the end, we wanted the story—and not the design—to be what people remembered."

"We spent a lot of time taking away extra information that distracted from the overall experience. Take, for example, the teasers we included at the Documentary-level experience. At first we designed each of them with a unique icon and tagline, such as 'Click here to explore a virtual dig site.' However, we found that this detail distracted from the emotional power of the film. So we decided to simplify with the universal tagline 'Learn more.' Because the icon is always the same, once the viewer has seen it, he can more easily ignore it when it appears later in the program."

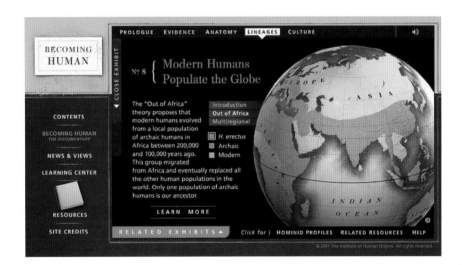

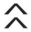

top. Users can either watch the documentaries or navigate to specific subjects, thus giving them control over their learning experience.

bottom. The layout of the copy is a paragon of simplicity. Each section offers a brief paragraph on the subject and a Learn More option. A great deal of information is easily available, but visitors who don't want it aren't burdened by it.

The Result

The resulting piece is extraordinary, a true measuring line for Web developers everywhere. The *Becoming Human* site should transform how people view the Web and how they envision its purpose in the future. Terra Incognita married a simple, themed graphic style and impressively organized material to create an educational experience unique on the Web today.

"Let the form of the solution be dictated by the needs of the content."

// DESIGN FIRM: **Accordion /** PRINCIPAL: **Tania Konishi /** ART DIRECTOR, Entire Media: **John Foreman /** DESIGNER: **Jordan Crane**

The Designer as Client

accordionbrand.com

The Accordion site is a textbook example of design creating the mood for the communication of an idea or message. By using shape and color to lead the eye to the information, the designers have created a site that relaxes viewers, allowing them the space and room to take in the information wholly, without distraction.

Accordion is a brand planning and positioning consulting firm that analyzes brands and makes recommendations for their marketing structure and creative requirements across all media and all audiences. Since 1996, Accordion has been involved in the production of countless new media initiatives, including CD-ROM production, video presentations, online brand creation, electronic commerce, Web-enabled databases, workflow automation over Intranets, and customized Web-based learning applications. The Accordion site was developed in a partnership with Entire Media, which specializes in creating new media content that combines the disciplines of information architecture, identity, and interactivity design.

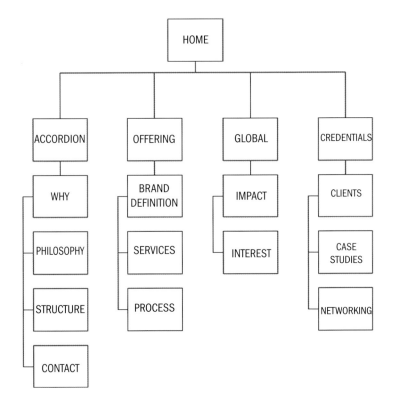

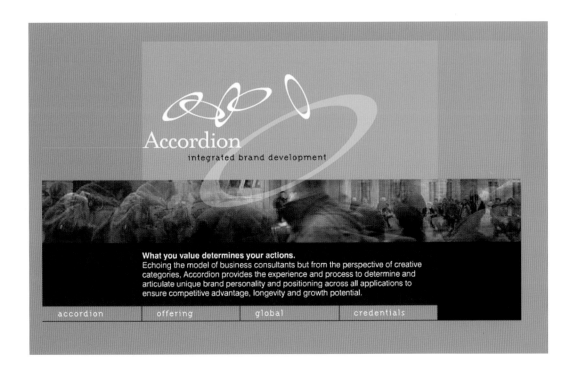

top. This simple but effective site map kept the client and the designers on the same track.

bottom. The rectangular inset reinforces the visually minimal approach by confining the content of the site.

right. Subnavigation is presented on rollover and is confined to the navigation bar, thereby leaving the entire upper area open for content.

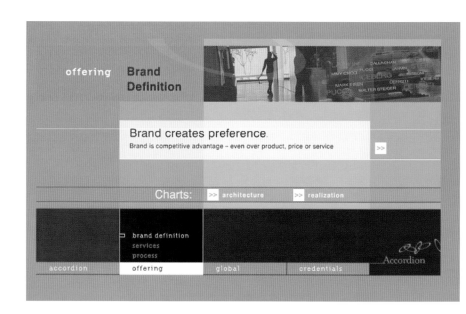

When the Designer Becomes the Client

Although Accordion deals in brand positioning, it is still in the business of design. At its core, it deals with the purposeful communication of ideas, as any design firm does. So what happens when the design firm uses an outside agency to develop its site? The table is turned, and the design firm becomes the client. Now the design firm must deliver its voice to another entity, working with the outside agency to accomplish the goals of the site. Accordion called on Entire Media to give its vision legs. "Entire Media, our media and technical partner, developed our site," says Tania Konishi, a principal at Accordion. "For a change, we were the client. We had the opportunity to practice our own process and found it successful, rewarding, and stimulating."

The design and production process was intended to be two-sided; Accordion planned to provide the outline of the message as well as all of the content. Konishi recalls, "We set the project in motion by providing a clear brief—the business task, the intended function of the site, the audience, the desired response, the required tonality. We were specific and realistic about what we would use the site for. Additionally, we provided a first pass at the architecture segmentation and draft copy for all sections."

"The most important aspect of the project was determining the content," says Jordan Crane, lead designer for Entire Media. "We spent the majority of our time with Tania hammering out just what we wanted the site to say. We worked on eliminating and conjoining the redundancies and hacking out the superfluous content. Once we had our message as bare and straight-forward as possible, we were able to determine what ideas would enhance rather than detract from the core message of the site. As we built upward from the central concerns, I was constantly reconfiguring our visual language and testing it against the content."

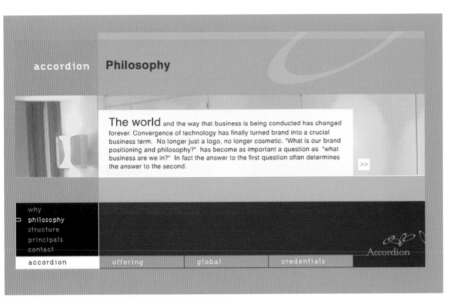

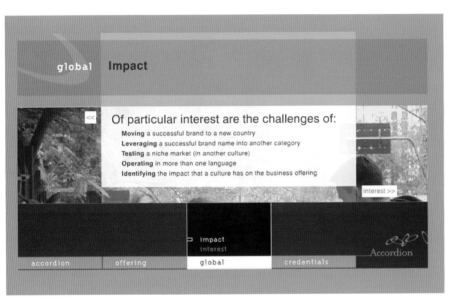

top. The designers chose to create *next* and *back* arrows for shuffling through section-specific content. This approach provides a clean, controllable environment by eliminating large pockets of copy.

bottom. Using *next* and *back* arrows to shuffle through content is a great way to simplify the interface, removing browser scrollbars and limiting the amount of text that appears on the screen at any one time.

Knowing the Obstacles

As creatives themselves, the people at Accordion knew what the designers needed to do their job. The content could have easily been left for last, as most design firms know what areas they want to include but haven't taken the time to dig up exactly what is going to be presented. The Accordion team, aware that this approach makes problems for the designers, provided the content to Entire Media at the beginning. "Often, the client is slow on delivering final content and the design process must move forward without the benefit of knowing what the final content will be," says John Foreman, principal and art director at Entire Media. "This was not the case when working on the Accordion site. Accordion provided us with a thorough design brief and the text content for the site as we kicked off the project. I wish this happened more often, as it leads to a much more tangible way of creating design communication solutions."

Navigation as the Brand

The navigation used in the site can almost be overlooked, it's so integral to the design of the site. To the team at Entire Media, the navigation is the most important aspect of a site. "From an image or branding standpoint," Foreman says, "the navigation, which is the user interface, is the brand. Any organization looking to leave the user with a positive image needs to develop the navigational system in accordance with its branding goals."

"Structurally," adds Konishi, "navigation provides the walls and the linkage of the layout, so it dictates the confines or freedom of site aesthetics. It also plays the role of a miming tour operator, guiding the visitor to identify the cues and then explore the space and the offering. A definite relationship is built between the user and this miming tour guide; if trust is secured, the experience (beyond the content) will be good. Navigation also provides a pace and rhythm to the site, which is often misunderstood or underutilized by designers. It is a key factor in the user's perception of how smart, efficient, or engaging the offering is."

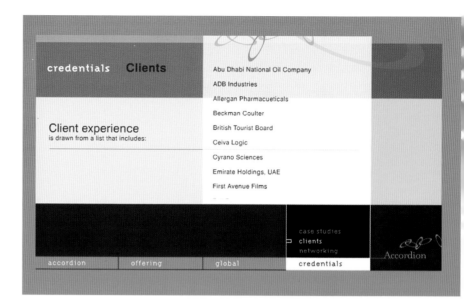

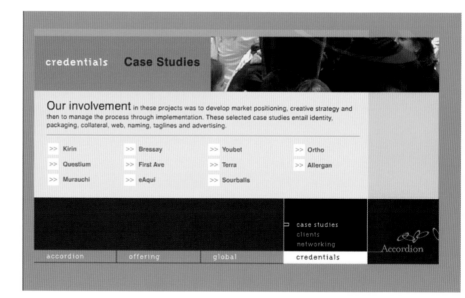

top. One of the bonus features of using Macromedia Flash as a design tool is the ability to scroll through content without the scrollbar the browser would normally provide. The designers used this functionality well, scrolling through long lists of content without having a scrollbar intrude into the design of the site or adding unnecessary visual clutter.

bottom. Tertiary navigation occurs in the content area, but instead of appearing alongside and competing with content, the navigation *is* the content, thus reducing visual clutter.

Letting the Designers Take the Site to a New Level

The site was so well-organized and planned that the Entire Media team had little to request or question. The process advanced quickly. The Accordion team attributed this to both a thoughtful plan of action and a talented design and production staff. "If you communicate well enough in a creative brief," says Konishi, "the technical and design team will lift the concept beyond what you had imagined. This is tremendously exciting and rewarding. We became alert and delighted passengers in the process. Entire Media kept shaping the concept and growing each level." This constant shaping allows the design staff the ability to constantly simplify the interface as needed.

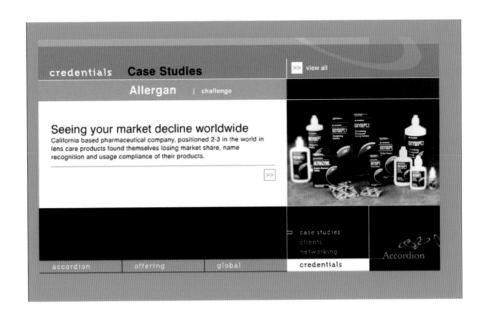

above. Portfolio images appear in the rectangular region to the right. Like the other key elements on the page, these images always appear in the same place, reducing the amount of searching or variance the user must tolerate to find information.

The Result

The design of the site was left to Entire Media, but the content was Accordion's responsibility. Together, the two firms structured a site that displays massive amounts of information in a clean and visually pleasing manner. "The pages are put together in such a way that only a phrase or two is visible at a time," Crane notes. "The pages are visually uncluttered—the largest concentration of lines and shapes draws the eye in to the place where the text is. Aside from the text, the page is visually simple, relying on basic shapes and colors, along with a horizontal format, to create a sense of repose, of relaxation."

"The balance of generous open spaces provides a minimalist experience," adds Konishi, "including the large orange frame and the horizontal interior screen, along with the tightness of the typography and the cropped images. This provides an intense, intimate one-on-one communication. Unfinished images are simple, elegant in format, and, at the same time, engaging to the observer."

"It is important that visual elements don't complicate
the site and make it difficult to understand."

Digital Storytelling

kodak.com/us/en/corp/features/birdcam2000/index.shtml

The Birdcam site, developed by Second Story Interactive, is a tribute to the designers who prioritized giving the users what they came to see. The flagship element is, obviously, the live birdcam. Many times, designers don't take the time to understand the reasons a user comes to the site nor what the user is there to find. Second Story understood the primary goal of this site—to present the birdcam. The simplicity of the site can be found in not only its visual style, but in its single-minded purpose.

Second Story, established in 1994, creates informative and entertaining interactive experiences for the Web and other digital media. The studio's team of creative artists, producers, writers, animators, and programmers has developed over forty award-winning interactive stories—from adventure travel, exploration, and drama to historical documentaries, biographies, and fiction. Each feature reflects Second Story's dedication to inspiring audiences through storytelling innovation.

Birdcam 2000 offers live coverage of peregrine falcons nesting high atop Kodak Tower in Rochester, New York. The live Web experience is blended with in-depth story modules to yield a hybrid site that both entertains and educates. From March to August, audiences can view live video images for a bird's-eye view of peregrine family life. Selected Birdcam images are archived in a gallery and can be sent as postcards. The interactive natural history modules correspond with the hatchlings' developmental milestones and are available as a resource tool long after the young birds have left the nest.

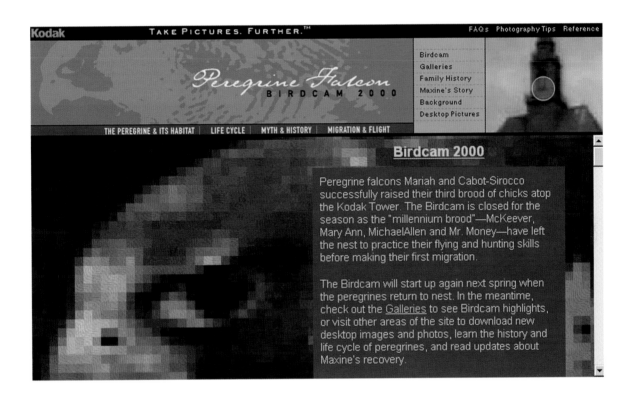

above. Two distinct levels of primary navigation eliminate the need for subnavigation and, therefore, allow the content to drive the site.

right. To generate visual interest as well as to minimize file sizes, the designers used single photographs and zoomed in and out on specific areas of interest within the image.

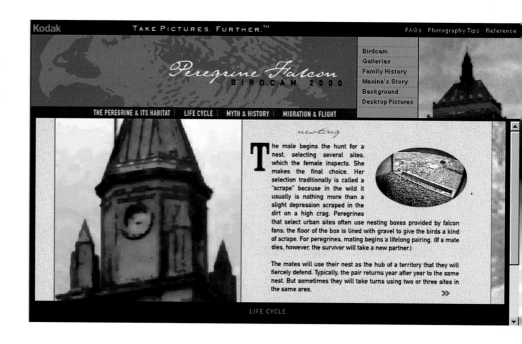

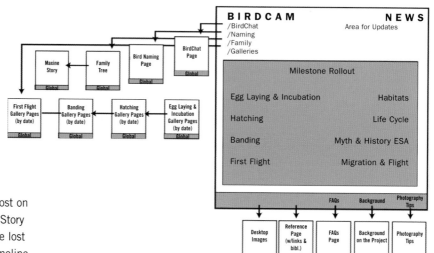

Digital Storytelling

The art of storytelling often gets lost on the Web, but the staff at Second Story Interactive is pushing to revive the lost art of weaving information into timeline-based structures. The Birdcam 2000 site is intended to be an educational discovery as well as a story, so the information needs to be both ecologically accurate and consistently interesting. The project presented a special challenge to Second Story in that Kodak asked the studio's team to do the research as well as the site development. Studio director Julie Beeler says, "The client didn't deliver any content except for photos from the previous year's birdcam. We were responsible for developing, researching, and presenting the entire site's content except for one component: the live birdcam."

above. The designers used a simple combination of a site map and a generic layout document to keep track of where elements would reside and how they would relate to other destinations.

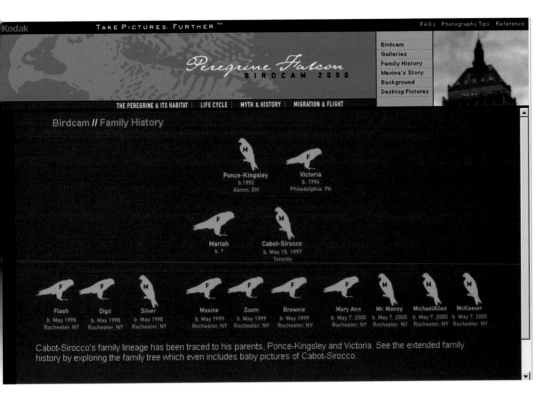

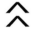

above. Sometimes, simplifying the interface is more about ease of use than visually minimal appearance. The designers happen to achieve both here by using silhouettes of the birds rather than actual photos, creating a smaller file and a simpler interface.

Organizing Content That Doesn't Exist Yet

It's difficult enough for developers to organize client-provided content, but the prospect of organizing content that hasn't yet been discovered would cause most designers to weep. The team at Second Story, however, makes a living by telling stories from books with blank pages. Beeler says, "Our first job was to determine the content itself. It was important to communicate the development phases of the peregrine falcon, and we wanted to create compelling, interactive modules that visitors could experience while viewing the live development of the birds. We built a simple blueprint/flowchart of the site structure and reviewed the scope of the content with the structure in mind."

Beeler continues: "The blueprint was the working example used to build a protosite. The protosite is a working text-only site that allows everyone involved in the project to experience the site's interactivity. There is often a disjunction between what we conceive of in the blueprint and how the site performs. As we interact with the site, we are able to look at its information flow, accessibility, intuitiveness, efficiency, and so on, and we continually update the site to hone the navigation and interactivity. We always do this prior to developing any visual treatments. We find it best to separate the experience from the visual skin. These are developed in parallel to one another. Once they have both evolved to a certain point, they are integrated."

The peregrine falcon soared high in the religion of ancient Egypt. From Egyptologists we get translations of the hieroglyphs that worship the falcon as "beyond the flight of the original bird-soul, beyond the stars.... beyond the limits of the divinely created universe..." The peregrine was worshiped as Horus, god of the sun, the great falcon whose divine eyes were the sun and the moon. In hieroglyphics, a sign for "god" was a falcon on a perch. Falcons were so revered that sometimes, like pharaohs, they were mummified.

Getting Users to the Most Wanted Content

The design of the site needed to mirror the intense organizational effort put forth to this point. Second Story wanted the site to appear rich in content but visually simple. "The nature of the subject is complicated and detailed," Beeler says, "so the site needed to communicate a lot of specific information in a simple, intuitive environment. I think the simplicity evolves out of the layout of the assets. Not all sections are minimalist, but the overall layout and approach to interactivity are. We tried to limit excess visual design by including only those visual elements that helped achieve our goals for the project."

"We felt it was important to give users a glimpse of the whole right up front. We wanted them to see all their options off the home-page and, more specifically, be able to view the birdcam images without having to click through pages. We felt that the sooner this structure was presented, the easier it would be for visitors to get an intuitive lock on the navigation. We particularly wanted to provide easy access for repeat visitors, for which this project was expected to have thousands."

"It was also important to refrain from overwhelming users. Although we wanted to present a lot of choices, we also wanted to visually identify and prioritize the content options to make it easier for visitors to select among them. On the other hand, we didn't want to oversimplify the site or give the impression that it is not very deep or wide."

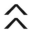

above. The navigation at the top remains constant, which is reassuring to users.

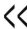

left. The designers used marvelous photographs as well as text to communicate ideas and information to the user.

bottom. The designers chose to use small arrows at the end of the copy rather than scrolling text to shift through content. This method not only allows the user to continue with as much content as she desires, but it also visually simplifies the interface by removing both the mass of copy and the scrollbar.

The Result

The site's overall look and feel is simple yet purposeful. "In the Web sites we have created," Beeler says, "we have always purposefully designed the site's architecture, navigation, and interactivity to be as simple as possible and as intuitive as possible. In order to achieve this, we have to depend on visual minimalism. It is great to see that this concept is evolving and that more and more Web sites are taking this approach."

"You need to create a message and a simple, focused form in which to express it to your desired audience."

Design That's Driven by a Company's Philosophies

factordesign.com

Using clean, straight lines and purposeful imagery, the site nearly sings with professionalism. One of its key design features is appropriate typography that mirrors its aesthetic layout. The site also mirrors the philosophy of Factor Design—that navigation should act quietly and effectively to allow the user to find the information as easily as possible.

Factor Design maintains offices in Hamburg, Germany, and San Francisco, California. The print-based and interactive projects the studio has developed on behalf of its diverse range of clients have been widely published and have received numerous awards.

The current Factor Design Web site is its second. "We approached the development of the new site with three primary objectives," says Jeff Zwerner, creative director. "One, to communicate the value and experience the Factor Design process provides for its clients. Two, to educate and inform clients about our process of developing solutions. Three, to extend and enrich the design vocabulary of Factor Design and the experience we use to communicate our philosophy and value online."

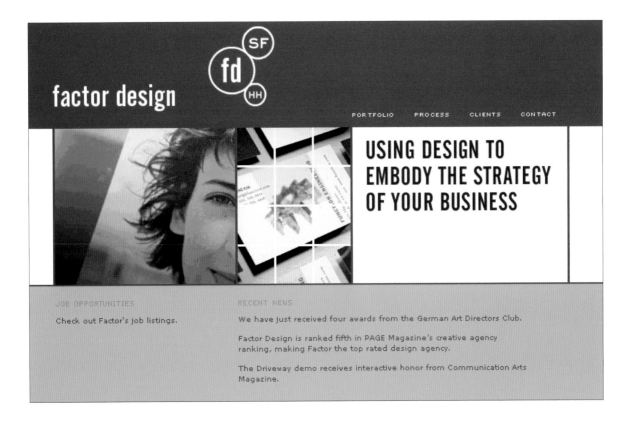

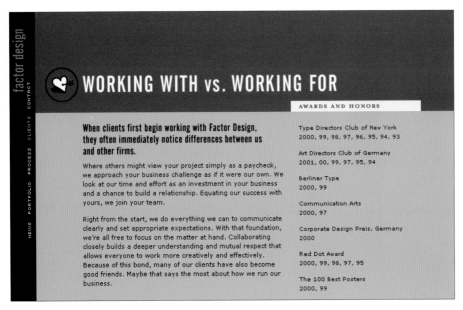

top. The mood is created by using muted colors and linear patterns, while focused, direct content presentation provides the user with an easy avenue to follow through the site.

bottom. Simple but effective icons, like the heart icon shown, provide visual relief in text-heavy areas.

The Offspring of Good Architecture

The layout of the site was not intentionally minimalist; it simply communicates the message without an overabundance of speech. "Visual minimalism is often associated with a single, targeted message or emotion," Zwerner says. "It is the result of using few visual and verbal elements on the page or screen. To achieve effective minimalism, you must clarify your objectives and communicate them powerfully."

"One of the dangers in attempting to distill information or messages to the bare minimum is that the emotion is lost along the way. Emotion is the driving force behind defining a tactile and memorable expression of one's self, whether in the form of personal communication or commercial communication. You need to create a message and a form for that message that will resonate with your desired audience."

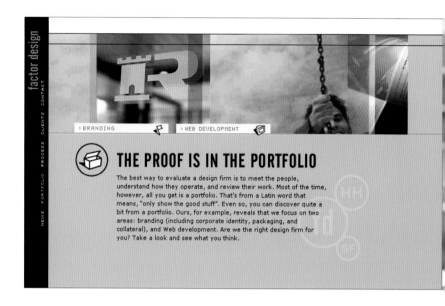

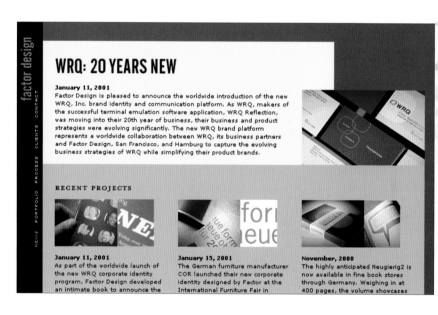

top. Using muted earth tones makes the saturated color imagery really pop.

bottom. Further simplifying the design, color and imagery, rather than words, were used to direct the user.

left. It almost goes unnoticed, but the page contains no photography or imagery, only stylish typographical treatments.

When You Are the Client

Unusual challenges emerge when designers create their own sites. Most designers are highly critical of their work, so when they are their own client, they struggle to be satisfied. Often, they try to be all things to all people, therefore saturating users with too many messages.

Knowing this potential pitfall, the designers chose to treat themselves as they would any other client with respect to organization and infrastructure. Zwerner says, "As we do with our clients, we forced ourselves to develop the content and architecture prior to beginning the site design. We require this because we need to understand the objectives, depth, and quantity of content before we can use design to communicate clearly and effectively."

Knowing what the site's purpose is, what the content will be, and to whom that content should speak drastically decreases design and production time. "Because we were intimately familiar with the content and objective of our internal site," says Zwerner, "we did not follow the architecture and navigational development path we usually employ on client projects. Typically, we first identify the business objectives, catalog and prioritize the content, then design the architecture and navigation scheme. This process involves the intense collaboration of the client and the Factor teams and over one to six weeks yields a paper-based architecture that is refined and tested. This architecture becomes the living document from which to work throughout the project." This document will serve to reinforce the importance of organization within site planning to achieve simple, concise, effective design.

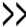

right. The designers didn't take section subnavigation for granted; they used relative imagery on the right to direct the user to the other areas of the section.

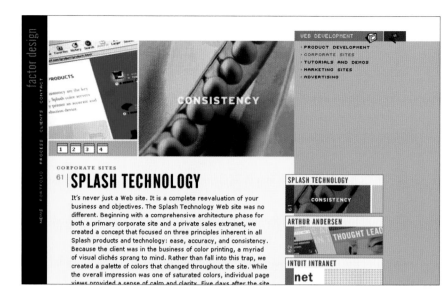

Navigation Should Be Almost Transparent

"Obviously, navigation is the primary mechanism that takes the audience from one point to another," Zwerner says. "Without a well-developed navigation scheme that is easily understood by the audience, the site will cause frustration and lose visitors, customers, and potential dollars. The navigation scheme should be as intuitive and transparent to the user as possible. You want to make sure users never feel disoriented or, even worse, lost."

"However, navigation is not the primary purpose of the experience. Users don't go to a Web site to find or buy navigation. They go there to find information or buy products. Why, then, does navigation often take precedence in the hierarchy of elements over the information that is the primary objective of the site?"

above. The site is built with traditional HTML code but incorporates areas of Flash to bring in multiple images that strengthen the section's message. Using Flash in this manner allows the designer to include multiple images within a predefined space, strengthening the overall visual simplicity.

above. Beautiful photography within the site adds to the overall clean and elegant atmosphere and offers the viewer visual rest.

No One Knows You Better

The Factor Design team also needed to present the content in a way both attractive and consistent with its internal philosophy. "The content communicates the primary goals of the site," says Zwerner. "We don't build a design around the client's content, we design content around the client's business objectives. We then develop the design to support and enhance those objectives and to reinforce the messages."

"The content for our site was developed internally in collaboration with a writer. We developed the concepts and explored the voice in which we wanted the writing to communicate. The writer then took those concepts and fleshed out all aspects of the site."

The Result

The site certainly accomplishes its core objectives. "We are always attempting to refine messages so that we can achieve the most direct communication with the intended recipient as possible," Zwerner says. "From each focused message we develop tools that pull at users' emotions and make them act accordingly. Sometimes those tools are the message itself, imagery, colors, or the overall experience of interacting with the message. The message is driven by the objectives of the business and is defined by the information we obtain about the ultimate consumer of the message."

"The style guide we created at the beginning of the project dictated simplicity, keeping everyone on track throughout the process."

Communication as a Two-Way Street

thenorthface.com

// DESIGN FIRM: Akimbo Design / DESIGNERS: Ardith Ibañez Rigby and Ben Rigby

The North Face site design mirrors the company's other marketing efforts. It combines awe-inspiring expedition photography with relatively neutral color schemes; simple, effective content framing; and well-used negative space.

Principals Ardith Ibañez Rigby and Ben Rigby founded Akimbo Design in early 1997. They anticipated the need for a Web design studio that specialized in front-end design and believed that a team of Web user-interface experts, people versed in both design theory and the minutiae of Web technology, could create unparalleled Web sites. Since its formation, Akimbo has been aggressively pushing the boundaries of Web design.

Thirty-five years after its start in the outdoor industry, The North Face offers an extensive line of performance clothing, equipment, and footwear. With the most technically advanced products on the market, The North Face is the choice of the world's most accomplished climbers, mountaineers, extreme skiers, snowboarders, and explorers.

The North Face came to Akimbo Design with no prior Web presence and asked the Rigbys to build a site from the ground up. "Initially, we were brought in by an e-commerce partner, Fort Point Partners," explains Ben Rigby. "We collaborated with Fort Point and The North Face to develop the site architecture, functionality specifications, and the general look and feel of the site. Through extensive brand analysis and user testing, we developed a design and architecture that expressed The North Face's powerful brand identity while allowing visitors to access extensive product information."

The North Face was comfortable with the negative space on this site, but don't be too hasty in labeling the site as an example of minimal design. "We wouldn't say that the site is minimalist," says Rigby. "It's certainly less cluttered than some sites, but it still conveys a lot of data in a small area. The feeling of simplicity comes from the use of common backgrounds and a consistent color palette, iconography, and navigation."

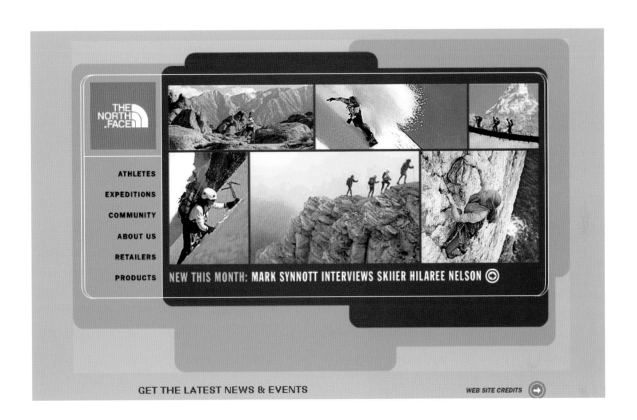

NEW THIS MONTH: MARK SYNNOTT INTERVIEWS SKIIER HILAREE NELSON

GET THE LATEST NEWS & EVENTS

WEB SITE CREDITS

above. The color scheme is strikingly fresh. It mixes well with the imagery and tone of the site and maintains the visual cohesion of many elements.

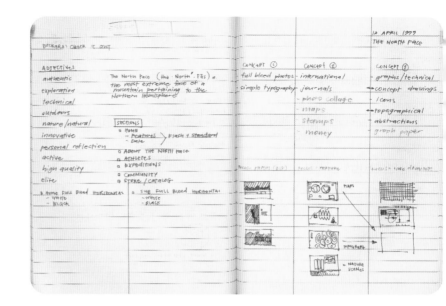

Starting at Base Camp

For Akimbo Design, the success of The
North Face site was hinged on asset
management and strict production
procedure. "The North Face has a huge
bank of expedition stories, expedition
photographs, athlete biographies,
technical product data, and technology
stories," notes Rigby. "We employed
our fairly developed process to lead
The North Face—and ourselves—from
concept to launch. We gathered all
content during the prototyping phase.
We used a variety of methods to create
the information architecture, including
flowcharts and visual storyboarding.
We then provided The North Face with
a series of four comps, from which they
chose the current look and feel. In all
of the sites we design, we strive
to create a simple and
intuitive interface because
we feel that it's usually
best for users and,
therefore, for the client's
objectives."

"We asked the client to choose
the design direction that best expressed
the brand and Web site objectives. We
refined the chosen design direction
once we reached a consensus. We move
forward only when the whole team is
happy and excited about the design."

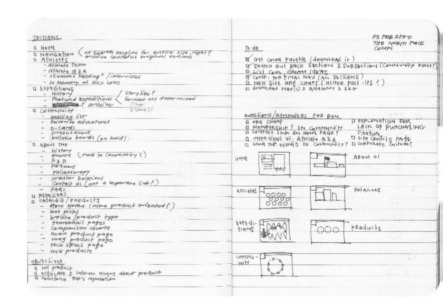

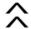

top. The notes here show how
the designers worked through the
content-organization process in both
a verbal and a visual way.

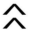

bottom. The informal wireframe of
the site provides an overview for
the designer to use during the
initial design process.

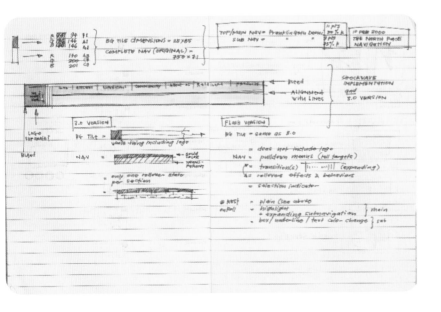

It's a Telephone, Not a Megaphone

To the team at Akimbo Design, navigation is simply a communication device. Navigation allows two entities to communicate with one another. While many designers concentrate on providing information to users, the Akimbo Design team focuses on a different objective. "We see effective communication as a two-way street," says Rigby. "In the case of Web design, there is a client, and there is a user. The designer is responsible for putting the two in contact through a Web site. Navigational elements enable users to engage in the information presented. *Effective* navigation enables users to find and use information intuitively, easily, and quickly, and it's the key to a successful design."

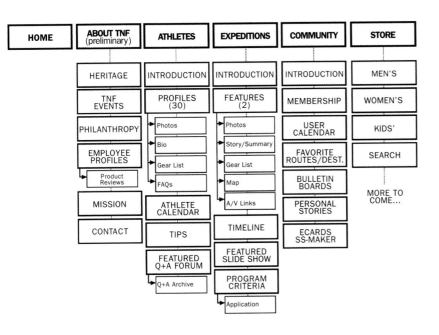

top. The designers paid a great deal of attention to the design of the navigation to ensure a complete experience for as many users as possible. With so much content, this was vital to the success of the site.

bottom. The formal wireframe provides clarity for everyone involved in the design process and allows both the client and the design team to visualize and create an intuitive structure.

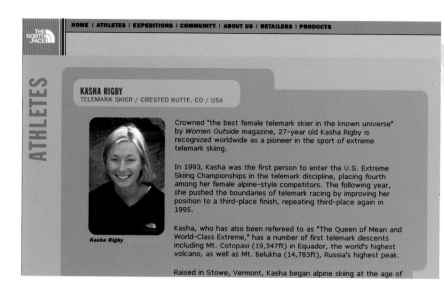

KASHA RIGBY
TELEMARK SKIER / CRESTED BUTTE, CO / USA

Crowned "the best female telemark skier in the known universe" by *Women Outside* magazine, 27-year old Kasha Rigby is recognized worldwide as a pioneer in the sport of extreme telemark skiing.

In 1993, Kasha was the first person to enter the U.S. Extreme Skiing Championships in the telemark discipline, placing fourth among her female alpine-style competitors. The following year, she pushed the boundaries of telemark racing by improving her position to a third-place finish, repeating third-place again in 1995.

Kasha, who has also been refereed to as "The Queen of Mean and World-Class Extreme," has a number of first telemark descents including Mt. Cotopaxi (19,347ft) in Equador, the world's highest volcano, as well as Mt. Belukha (14,783ft), Russia's highest peak.

Raised in Stowe, Vermont, Kasha began alpine skiing at the age of

Knowing What You Have to Work with

Obviously, the vast amount of content The North Face had was important to the overall effectiveness of the site. Even more important was getting this information as early in the production timeline as possible. "Content plays a crucial role in designing anything," Rigby says. "Without an idea or understanding of the content, the design is an empty shell. Design before or without content is like saying 'Function follows form.' That seems backward to us."

"We helped shape The North Face content, but the client was responsible for the lion's share of content creation. We designed around the client's objectives. We gave suggestions and scheduling advice, offered edits, and helped establish project priorities and realistic expectations. At present, we constantly check the content for accuracy, completeness, and consistency. For the most part, we help recraft the language of the copy to accommodate real people."

JULY 2001
FEATURED EXPEDITION

VIEW EXPEDITION ARCHIVE

ALASKA RANGE EXPEDITION
Ruth Gorge, Alaska. Photo by © Jared Ogden

WARNING: EXPLORE SAFELY!

top. The rounded angles, the icy blue palette, and the top-heavy navigation make the site easy to read and comfortable to experience.

bottom. The expanding menu along the top, which never moves, keeps the site open while providing a wealth of content choices for the visitor.

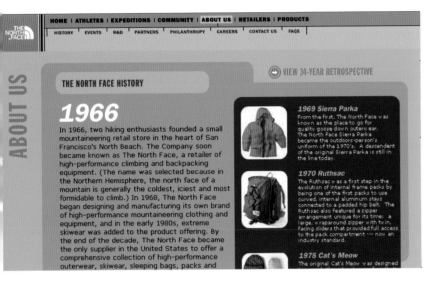

left. Nearly every content page contains areas of the site that the navigation doesn't include. Here, the View 34-Year Retrospective links to intriguing content the visitor would find only through exploration.

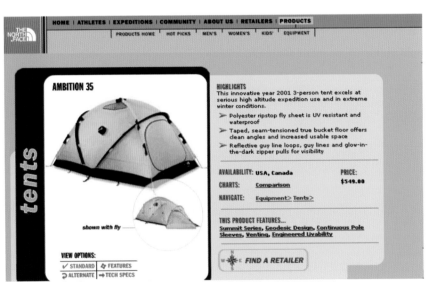

The Result

"Most brands apparently feel they need to use every available space on a Web page to sell or promote something," says Rigby. "On top of that, the trend is to animate as much as possible. All designers constantly struggle with clients who are uncomfortable with blank space and static imagery." The North Face site does an excellent job mirroring the attraction their audience has for the outdoors.

above. The designers added a magnifying feature to the Product Images section that allows users a more detailed look at each product. Features like this help simplify the pages by presenting only essential information up front.

> "Minimalism is really just erasing all doubt about where you want eye flow and behavior to go."

//DESIGN FIRM: **Bam! Advertising** /CREATIVE DIRECTOR: **Derek Carlin** /FLASH DEVELOPER: **Jason Lara** /DESIGNER: **Mike Bevil**

Letting the Site Map Evolve

bamadvertising.com

The Bam! Advertising site uses thoughtful organization to invent purposeful navigation and content presentation. The content presentation alone allows the interface to remain open and easily navigated. This combination of appropriate navigation and user-initiated content presentation provides an easy-to-use and enjoyable environment.

Bam! Advertising is a strategic marketing and creative boutique that specializes in marketing to both consumers and other businesses for technology clients.

The entire agency was involved in creating both content and design for the Bam! Advertising site. Bam! did not want to restrict the project to a few select staff members. "Developing the Bam! site was an exercise in organization," says Jason Lara, the lead Flash developer. "From content collection to task dissemination to personnel coordination, organization was the key to this project's completion. We decided as a company what should be included, and input from everyone was taken into consideration, from the founders to the interns. The site was meant to reflect the company, so every opinion was deemed important and was listened to."

"The main purpose of our Web site is to present an online portfolio of our work," says Bevil. "The desired functionality drove the design execution of the site. Our designers were tasked with creating a site that quickly and intuitively displayed a lot of content and large graphics—yet was still cool and had a strong graphic expression. It had to be clean yet deep, very designed yet simple."

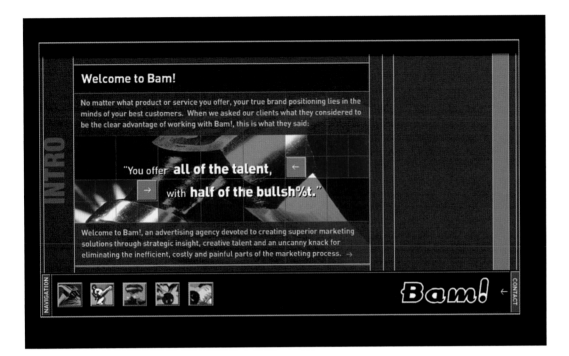

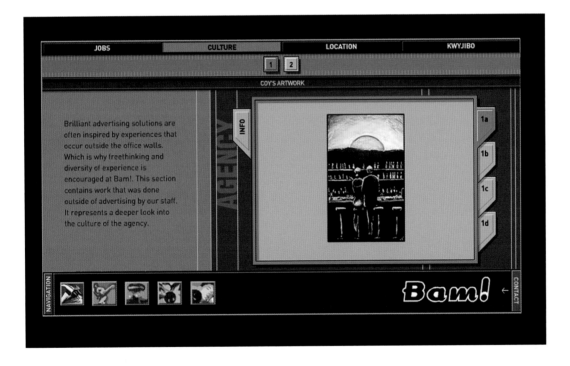

top. The linear layout and iconographic navigation cleared space for content that does not seem to be compressed or forced into small spaces.

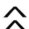

bottom. A simple second-level subnavigation bar appears at the top of the section layout, available yet not intruding on the content.

Large Content versus Vast Content

A common dilemma for design agencies working on their own sites is the delicate balance between showcasing their work for other companies with their own corporate image. Bam! Advertising, to overcome this problem, drew on the opinions of everyone in the agency to find common ground. Bevil, a founder and one of the writers for the site, says, "We laid out what we wanted our site to communicate and what functionality we wanted it to have, then put the design skin on that interface."

With so many opinions about what the site should say and how, it was paramount that the developers clearly state the design process to be followed so that everyone could be on the same page during production. "We next had to decide what ideas, elements, and other content would make it into the site," recalls Lara. "After that, we had to build a delivery framework. This was

critical to the timely completion of the site. Once this framework was complete, we could make a site tree, assign tasks to teams, and begin production."

Creating simplified organizational documents is hard enough with consistent content, but when that content is drastically varied, the challenge is even greater. "From the beginning, we knew the general message we wanted to convey," notes Derek Carlin, creative director. "The job was to devise an easy-to-use navigation scheme and a look that fit Bam! Advertising as an agency. This was a lot more difficult than it sounds. There was a lot of content to include and, of course, an internal audience with a critical design eye to please. We used a tree structure to devise the site map but decided to keep the site map simple—nothing too specific or detailed—so changes would be easy to implement."

above. In the upper-left corner, the designers sketched the site's overall look and feel, going so far as to work out the placement and replacement of navigational areas.

Wireframing Can Evolve as Well

Plenty of content was available in-house, of course; the problem was deciding what was important enough to keep and what had to be trimmed. Says Lara, "Content influences the how and the why of the design decisions that are made when creating, testing, and publishing a site. If the content is awful, the site can be no better. I don't care how wonderful a method of delivering information you create, if the information delivered is bad, the site is bad. Always remind yourself, 'There's a name for garbage in a pretty bag—garbage.'"

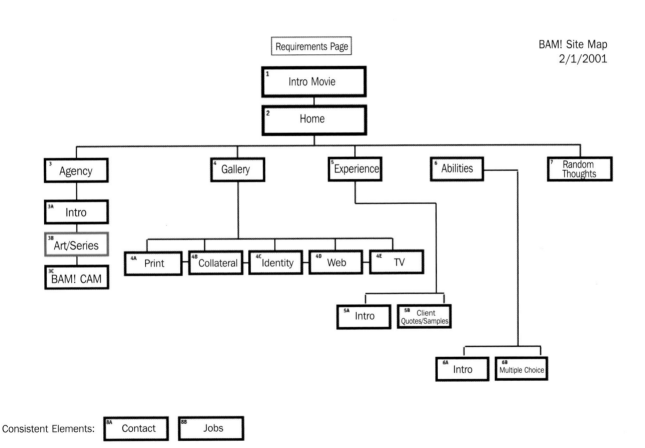

BAM! Site Map
2/1/2001

above. Although fairly simple in structure, the site map kept everyone in the agency focused.

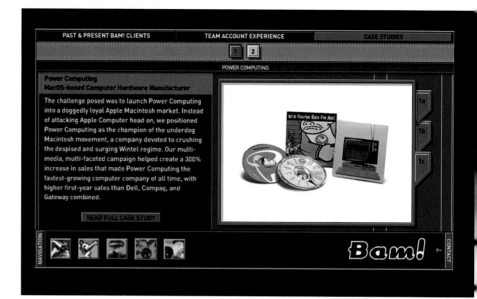

Breaking Down Navigation into Simple Structures

The navigation is arguably the most significant structure of the Bam! Advertising site. It works from the beginning to foster an overall impression of clear, concise, simple design. Incorporating navigation that is functionally clear and visually interesting is the foundation of any site, according to the team at Bam!

"Navigation is the pivotal element of effective Web design communication," says Lara. "It is the point of contact between the user and the content. An effective navigation scheme can be defined as having the right balance of interesting visual design and intuitive interaction design. Some sites focus so much on making their navigation avant-garde or cutting-edge that they lose their audience."

Carlin agrees. "A navigation scheme may be unique to a site, but as long as it is intuitive, then it should be successful. The Web is about exploration, the finding of information, and the sharing of new ideas. But if you bury the content, chances are it will not be found. The attention span of browsers on the Web is short, for the most part, and one should structure content and navigation with that in mind. Always think about the audience."

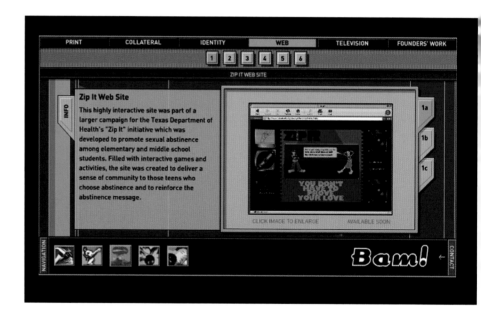

top. The designers chose a tab metaphor for shuffling through content. This eliminated the need for scrollable content and makes the variety of examples available throughout the stay.

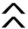

bottom. For shuffling through section areas, the designers used another iconographic presentation. Its numeric titles simplify adding areas to the section.

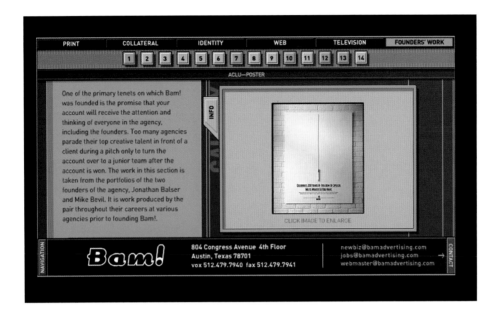

above. Wanting to make contact information available at all times, the designers built in a sliding contact bar along the bottom. This makes content available but not visible, which maintains the visual simplicity.

The Result

Designing the overall look and feel of the site was a collaborative effort, just as the other steps of the development process had been. With multiple teams working simultaneously on the project, it might have been easy to get sidetracked, but to their credit, everyone worked in unison. "The writers created the copy while the designers created a look and feel that allowed the developers to create a site that could contain and display the vast amount of content available in an interesting and intuitive way," noted Carlin. "One of the most interesting aspects of the production of BamAdvertising.com was how smoothly the teams worked together. As the developers finished creating the framework for sections, the content creators delivered to them their assets, which were then implemented. Thanks to the front-end planning and the constant communication among the teams, this content-heavy site was produced on schedule, and little tweaking was needed after delivery."

The developers created a site that is content intensive but easy on the eyes. "Visual minimalism, in a design sense, usually consists of including only the bare necessities," says Carlin. "I like to think of the Bam! site's minimalism in a more traditional, fine-art sense—as the simplification of form. I think the hard, clean angles and few colors conveys a sense of simplicity."

How to Inform Intelligently

britesmile.com

Britesmile.com clearly shows what effective organization and clear, concise architecture can do. The subtle imagery presentation allows the content to be the focus of the space, and the intelligent navigational considerations provide a simple to use and understand service-related site.

Envision Interactive was founded in 1998 to design for the Web and for interactive media. The staff believes that design is a manifestation of information, and it is the studio's goal to create visual systems that allow people to comprehend Web sites as complete entities as opposed to a collection of individual pages.

BriteSmile, a leading provider of teeth-whitening services, wanted to redesign existing content from a previous site to better communicate and brand the service. Because the new site's purpose was information and branding, the content reception schedule was paramount. "We were fortunate to have received content early on," says Spencer Lum, the senior creative director at Envision Interactive. "We reworked existing information for our new site architecture and design. The rest we developed with a copywriter."

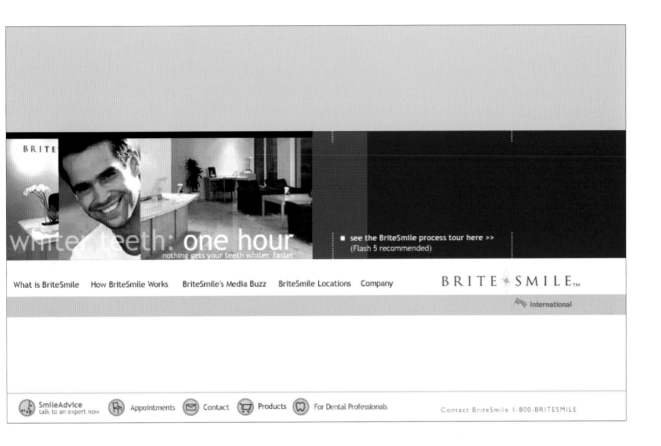

above. The top of the page is bare of content, providing focus as well as visual breathing room.

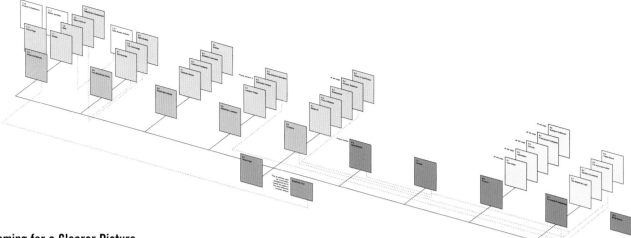

Wireframing for a Clearer Picture

Lum says of his studio's development approach, "Content comes as early as possible in our process although, due to real-world constraints, often it does not come as soon as we would like. Generally, we require final content about midway into the project; however, site architecture itself is actually the first thing developed."

Rough wireframe organizational outlines were used internally to keep the site architecture focused and understandable. "We build out sites initially through a wireframe diagram of the site," Lum says. "This tree map is the framework we use internally for the site. It helps guide us through the entire project, though the materials we present to clients are generally a bit more polished than those we use internally. We have found that simple wireframes allow us to effectively work with information, comprehending it and altering it as well."

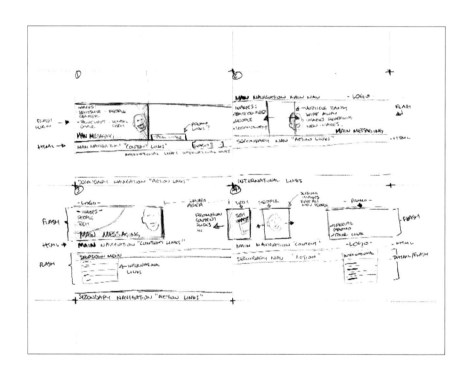

top. A formal navigational wireframe presents a bird's-eye view of the entire project and keeps teams of developers on the same track.

bottom. Secondary navigation is labeled Action Links. This name is intended to invoke an active response from the user.

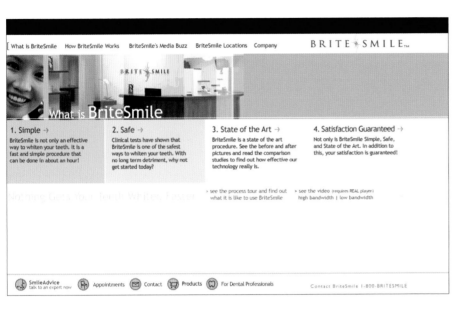

left. The site was constructed in a strong horizontal layout, with navigation clearly directing the user to additional content.

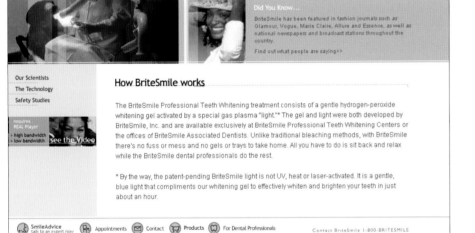

Navigation as a Design Element

A key element in the overall success of the site is clear, usable navigation. "Navigation is nothing short of critical to effective design communication," notes Lum. "If the information architecture is the foundation for a site, the navigation is the realization of that foundation. It not only allows users to get where they want to go but, on a higher level, it can be used to influence the way people move around a site, leading to stronger usability and strategic direction."

above. Navigation remains in the same place throughout the site, even as far as the third-level navigation on the left. From page to page, the viewer always knows where to find that level's navigation.

The Inclusion of Content as a Designed Element

The design of the BriteSmile site had to clearly communicate the procedure and benefits of the procedure as well as brand the company providing the service. The thin line between branding and information is often tough to walk. "It is our belief that content and design should function as a single, holistic entity," Lum explains. "While many projects force us to design around the content and in others the design effectively is the content, we don't feel that the two can be fully separated. Design is a manifestation of several factors, including branding, architecture, and usability, and we believe that all of these are strongly interwoven with content."

"For example, on britesmile.com, the internal promotional area that appears on many pages is designed to drive users deeper into the site. It was necessary to create content for these promotional areas and to adapt the content on target pages to reflect an awareness that some users would be coming through by means of a promotion."

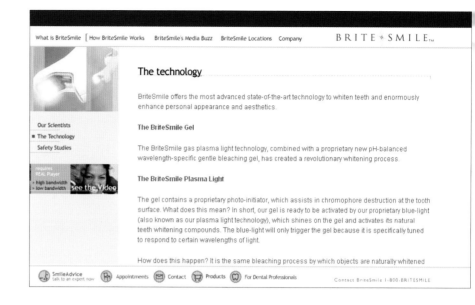

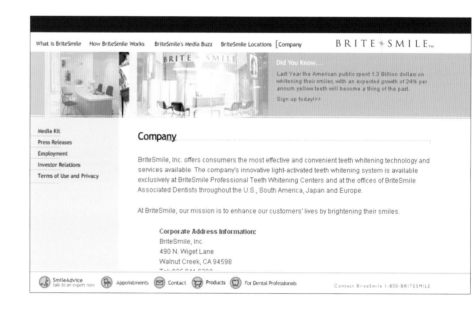

top. The designers removed most of the graphic content from this level of the site, understanding that viewers who have gotten to this point are interested in the content, not the images. The idea here is to make it as easy as possible to retain information.

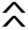

bottom. The Did You Know feature is a smart addition. The viewer is led methodically through testimonials, quotes about the service in the media, the company's satisfaction policy, and, finally, to a screen allowing the viewer to make an appointment.

The marriage of content and design is one of the most appealing characteristics of the britesmile.com site. This is no accident. "Content factors significantly into the design of the site," Lum says. "Without the content, in fact, it is extremely difficult to design an intelligent site. For example, Web sites must be navigationally effective. However, without content, there is no way to know how to structure the navigation, what type of visual hierarchy to create, or even to know the style of the design. Design is a visual communication vehicle. As such, it should be intertwined with the content that exists."

"On a higher level, creating purposeful design requires strategic thought as well. The user experience is not limited to the way the user navigates the site. It involves the manner in which the site directs and drives users to areas that they wouldn't go to otherwise."

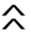

above. The designers added a Tour feature that walks consumers through the sign-up process, reinforcing the simplicity of use the site displays.

The Result

The elegant mixture of content and design creates an optimal user experience. Lum says, "BriteSmile is a high-end product with a sophisticated clientele. We had to make a decision—should we opt for an information-dense clinical site, or should we move toward a site that focused more on BriteSmile's core marketing strengths and differentiators? We opted for the latter, which lent itself to the minimalist approach.

"Minimalism in the design world is commonly understood to be a lack of elements. I believe that this cannot be the case because design, unlike many forms of art, is inherently a tool meant to communicate a point. In our work, we try to focus on the design of the information and the visual interfaces necessary to express the content."

"A lot of people don't understand that minimal
can still be useful."

Remaining Objective about
Personal Design

kilosite.com

Tim Parsons' Web site is a simple, purposeful, intriguing site void of useless graphic treatments and corporate babble. The small, constrained content area with surrounding imagery focuses the user to the content area. Using a square-shaped layout also allows Parsons to communicate in a flexible manner, adding and subtracting content easily due to the naturally blocked content area.

Parsons is a freelance graphic designer and, like many others, especially those who specialize or excel with new media, he relies heavily on his Web presence to reinforce his work in the field and to bring in new business. Also, like other freelance designers, he has many skill sets and is passionate about what he does. "I have extensive experience in all areas of design, project management, typography, interactive media, and print production," Parsons says. "My objective is to create constantly, but in the core of design, I am especially fascinated by functionality and how it affects design as a communicative device."

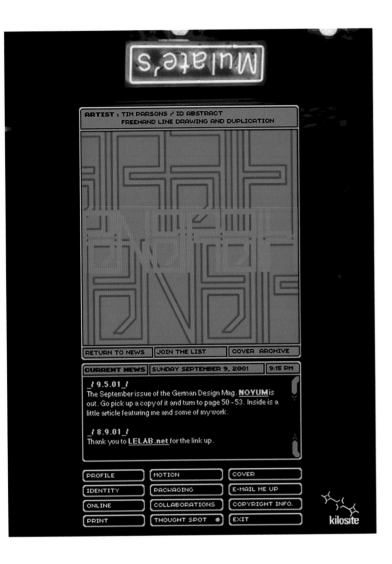

above. The wide frame surrounding
the active content area makes it feel
more accessible.

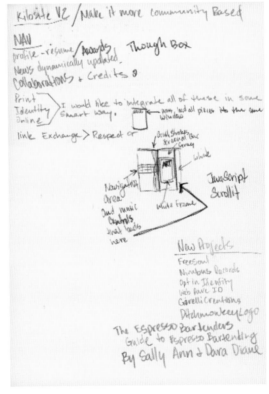

above. Parsons' notetaking allows him
to not only remember thoughts but to
question those thoughts later in the
design process. Here, the designer
reminds himself to stay focused on
the community aspect of the intended
purpose.

When Your Most Difficult Client Is You

Kilosite, Parsons's Web site, is meant to promote his talents by showcasing his work and as an example in itself. The common question for all designers creating sites to display their talent is: How far to go? Should the site be a technological marvel with more bells and whistles than any client could possibly want, or should it show restraint and refinement? The choice, obviously, is completely up to the designer. The problem is that the designer is probably not the right person to answer the question. "When designing something for myself," Parsons says, "I'm my own worst client. I'm just too picky and detail oriented when it comes to my own work, so the project ends up taking too much time."

"I'm constantly thinking of ideas and how pieces will fit together," he adds. As for many of his counterparts, the reevaluation involved in producing the site never ends. The solution is organization and discipline. Treating yourself like a client generates the perspective needed to clear the largest hurdle you'll face: simply organizing your thoughts and beginning with the production process.

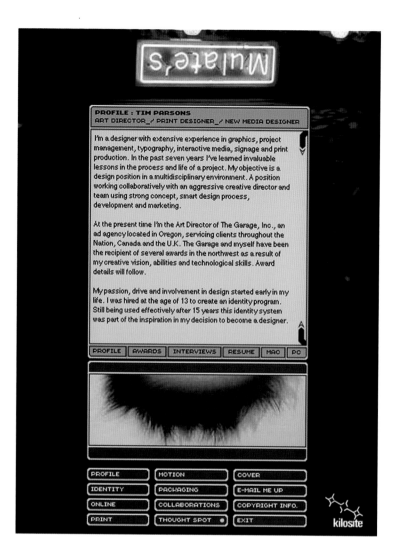

above. By creating small, tucked-away subnavigation, the designer dedicates the largest portion of screen real estate to the content.

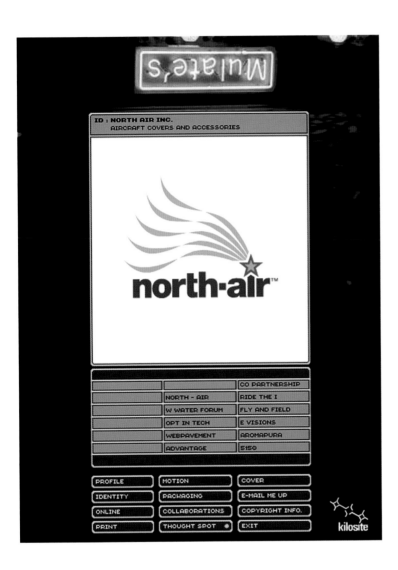

left. The primary navigation is not only recognizable but also provides a grounding element.

Examining the Importance of Content

Parsons chose to employ the process he uses for his clients. The first task is to find out what the purpose of the site is and to whom it is designed to speak. To do this, Parsons put himself in the shoes of his intended audience, then answers these questions from that perspective: What do I want to see first? What do I want to see last? He says of this exercise, "It's like putting a presentation together with an intro-duction, a body, and a conclusion."

Not Losing Focus of Your Audience and Their Needs

Creating the information architecture first allowed Parsons the perspective he needed to communicate with his audience, and it also provided him the overall perspective to create a visually simple design. Parsons' goal was to convey to potential clients his own philosophy and understanding of global site geography and naviga-tion. "I wanted the navigation to be so easy to understand," says Parsons, "that even your mother could use my site without getting lost and confused. For my navigation to be effective, I had to make sure everything was easily accessible at any time and in every section of the site."

Choosing Not to Overdesign

Once the site map was completed, the production process became a matter of design and execution. The steps Parsons took to organize the site content at the beginning afforded him the convenience of perspective, something most designers find a priority when designing their own materials. The design of the site just needed to accomplish the goals already laid out. Parsons wanted to make the simplicity of the site map show in the design of the site. He chose to use the content of the site as a design element as well, carefully selecting sections of previous work to create visual interest and to reinforce the expression of his talent as a designer. As for most designers, his biggest challenge from this stage was to avoid overdesigning the interface.

"For the background of the site, I used photographs that I've taken over the years," says Parsons. "Instead of making the whole photo visible, I show only a part of it. This way the audience isn't just looking at a photo—the background also adds a purposeful dimension to the design. The colors that I use are muted so the visitor's eyes naturally drift toward the content of the site. My navigation and the palettes float in the middle of the large photo, creating open space around the content. Simple typography for the navigation and descriptions also adds to the site without cluttering it."

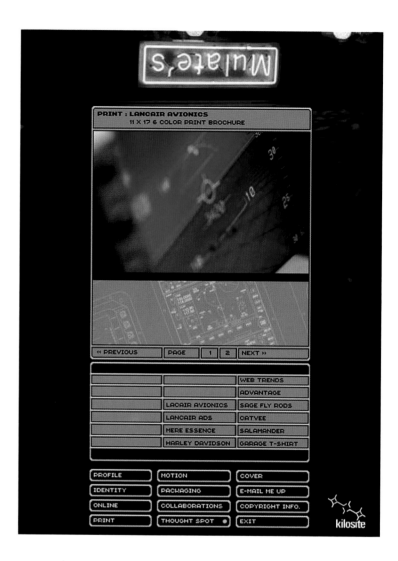

above. The use of neutral grays and contrasting shades helps bring the full-color content to the attention of the user, who thus can focus on the message rather than its delivery.

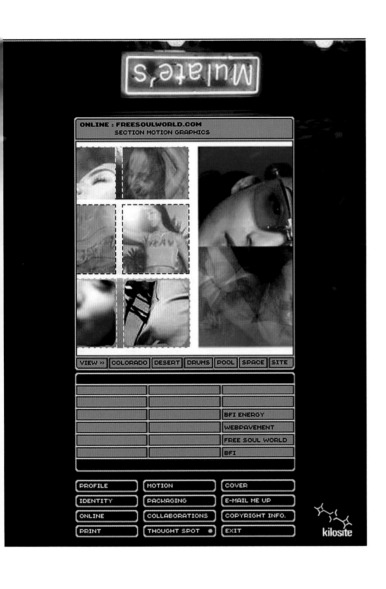

left. Anticipating future additions to the site, the designer thoughtfully built blank subnavigation areas for later use. This ensures that the site will not grow cluttered.

157

» http://www.kilosite.com || SIMPLE WEB SITES

The Result

The site demonstrates not only Parsons' work but also his ability to focus on the objectives of a project. Its expressive restraint attests to his professionalism. "There are sites out there," Parsons says, "where the creator says only, 'Hey, I know how to do this, this, and this,' then throws it all together, adding sound that is useless, graphics that have no purpose, and so on." This perspective has given Parsons the ability to understand and implement simple yet effective design structures.

Accordion Brand
3201 Barry Avenue
Los Angeles, CA 90066
(310) 313-2575
www.accordionbrand.com

Arhaus Furniture
DigitalDay
395 Springside Drive
Fairlawn, OH 44333
(330) 668-6669
www.digital-day.com

Andrew Lin
601 Leavenworth Street, #54
San Francisco, CA 94109
(415) 948-9549
www.androo.com

Automat
kegelgasse 14/12 | 1030
Vienna
+43-1-712 22 67
www.automat.at

Axiom Studio
441 North 5th Street
Philadelphia, PA 19123
(215) 509-7686
www.axiomstudio.com

Bam! Advertising
804 Congress Avenue, #400
Austin, Texas 78701
(512) 479-7940
www.bamadvertising.com

Big Man Creative
23412 Moulton Parkway, Suite 220
Laguna Hills, CA 92653
(949) 206-9806
www.bigmancreative.com

BriteSmile
Envision Interactive
20 S. Santa Cruz, #103
Los Gatos, CA 95030
(408) 399-5293
http://www.envisioninteractive.com

Factor Design
461 Second Street, Suite 202
San Francisco, CA 94107
(415) 896-6051
www.factordesign.com

Golf Info Austria
world-direct.com
Grubenweg 2
6071 Aldrans
Germany
+43 512 344713
www.world-direct.com

Hornall Anderson Design Works, Inc.
1008 Western Avenue, Sixth Floor
Seattle, WA 98104
(206) 826-2329
www.hadw.com

How It Works
1014 4th Street
Anacortes, WA 98221
(800) 664-6623
www.howitworks.com

New Tilt
48 Grove Street, Suite 206
Somerville, MA 02144
(617) 591-0400
www.newtilt.com

Paul Edward Fleming
5 Walmsley Boulevard, #D
Toronto, Ontario
Canada
M4V 1X5
(416) 831-0733
www.pauledwardfleming.com

Terra Incognita
301 Jackson Street, Suite 202
Alexandria, LA 71301
(318) 443-7833
www.terraincognita.com

The North Face
Akimbo Design
406 Chestnut Street
San Francisco, CA 94133
(415) 677-9250
www.akimbodesign.com

Tim Parsons
tim@kilosite.com
www.kilosite.com

Redpath Photography
Practicing Farm
stephen@practicingfarm.com
www.practicingfarm.com

Rob Allen Photography
Overdrive Design
37 Hanna Avenue, Suite 224
Toronto, Ontario
Canada
M6K 1W9
(416) 537-2803
www.overdrivedesign.com

Second Story Interactive
1104 NW 15th Avenue, #400
Portland, OR 97209
(503) 827-7155
www.secondstory.com

300 Feet Out
Pier 9, Suite 117
San Francisco, CA 94111
(415) 477-9940
www.300feetout.com

vFive
650 Delancey Street, Suite 112
San Francisco, CA 94107
(415) 227-9885
www.vfive.com

VenusDesign
Pixelizer
me@pixelizer.de
www.pixelizer.de

Villa Mt. Eden
Werkhaus Creative Communications
1124 Eastlake Avenue E
Seattle, CA 98109
(206) 447-7040
www.werkhaus.com